Learn to Paint
GOUACHE

Moira Huntly

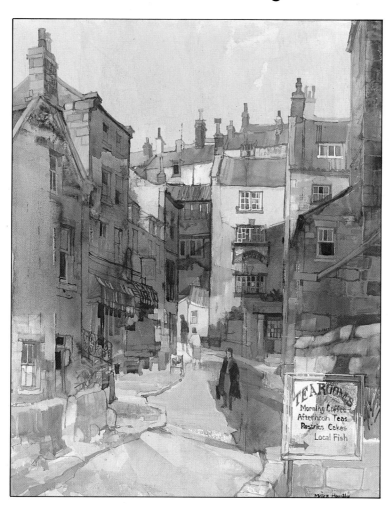

HarperCollins*Publishers*

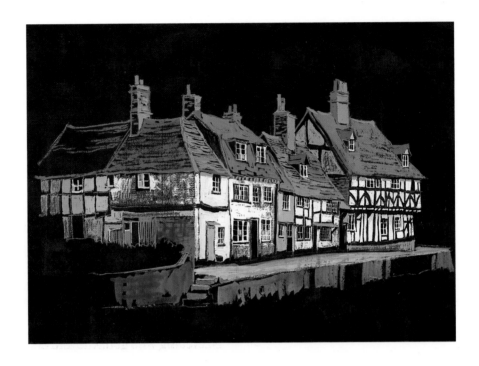

First published in 1989
by William Collins Sons & Co. Ltd
London · Glasgow · Sydney
Auckland · Toronto · Johannesburg

Reprinted 1990
Reprinted by HarperCollins Publishers 1991

Layout and editing by TL Creative Services
Filmset by Ace Filmsetting Ltd, Frome, Somerset
Colour reproduction by Bright Arts, Hong Kong
Photography by Nigel Cheffers-Heard

British Library Cataloguing in Publication Data
Huntly, Moira
Learn to paint with gouache—(Learn
to paint series)
1. Gouache paintings. Techniques
I. Title
751.42'2

ISBN 0 00 412347 6

Printed and bound in Hong Kong

CONTENTS

PORTRAIT OF AN ARTIST
MOIRA HUNTLY

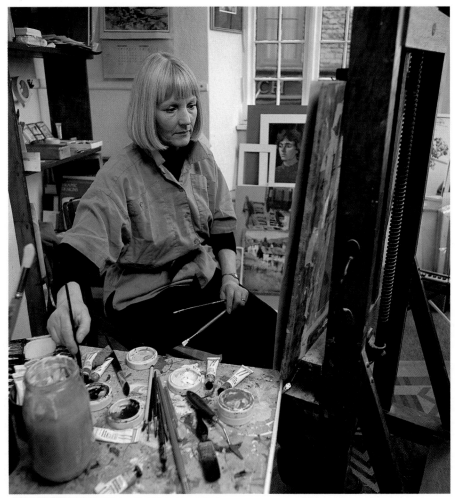

Fig. 1 Moira Huntly at work in her studio

Moira Huntly was born in Motherwell, Scotland, but when she was only a few weeks old her parents returned to Northern Spain, where Moira spent her early childhood. At the outbreak of the Spanish Civil War, Moira and her family were hurriedly rescued by a naval escort from the destroyer *HMS Whitshed* and became refugees in Portugal for a while, eventually returning to Britain penniless but safe. Since then, Moira Huntly has lived on the Wirral in Cheshire, and later in London where she studied for five years at Harrow School of Art and for a further year at Hornsey College of Art. She received a thorough and disciplined grounding in drawing and painting, and gained a London University degree in art teaching.

Her obsession with drawing and painting showed itself at a very early age, sometimes to the annoyance of her parents when they found drawings on the walls and even pillowcases if there was no paper available. Moira Huntly believes that it is instinctive for all children to draw and paint but that, as adults, we tend to lose our natural freedom of expression. She firmly believes that anyone, whatever age, who really wants to draw and paint can achieve a measure of success, a philosophy that forms the basis of much of her teaching and writing.

She has contributed to *The Artist* magazine and is the author of several books on drawing and painting. Her first books were *Draw Still Life*, *Draw Nature* and *Draw with Brush and Ink* in a learn to draw series. Moira Huntly's interests cover a wide range of subject matter and she is also author of two other books, *Painting and Drawing Boats* and *Imaginative Still Life*.

Besides marine subjects, Moira likes to paint buildings, figures, landscapes and industrial subjects, and is also intensely interested in the less dramatic, ordinary

4

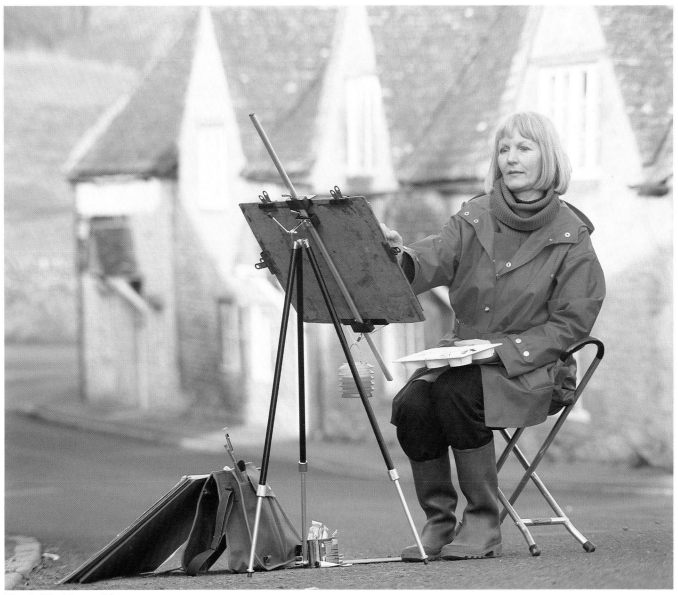

Fig. 2 Working outdoors

objects and scenes of everyday life, such as mundane kitchenware, the corner of a garage, a tool kit, drills and spanners or a vase of flowers. Moira Huntly has found gouache to be an ideal medium for depicting these varied subjects, its versatility enabling her to combine transparent washes of thin gouache with thicker overlaid or broken textured paint as a starting point in producing imaginative images. She also paints in oil, watercolour, pastel and with mixed media.

Over the years her work has developed to produce a very individual style in which her ability and love of drawing are very evident. These assets, coupled with a painterly way of seeing and expressing her thoughts, combine to produce work of considerable interest and vitality.

Moira Huntly was elected to the Pastel Society in 1978 and to the Royal Institute of Painters in

Watercolours in 1981, and she is a Council member of both societies. In 1985 she was winner at the Royal Institute's Annual Exhibition in London of the Winsor and Newton Prize for the best group of paintings by a member, and in the same year she was elected to the Royal Society of Marine Artists. In 1986 she was winner of the Laing National Painting Competition.

At present Moira Huntly lives in the Cotswold village of Willersey and is a partner in the John Blockley Gallery and studio in Stow-on-the-Wold, Gloucestershire. The gallery shows a continuous display of Moira's work. She also exhibits regularly with the Federation of British Artists at the Mall Galleries in London, as well as in a few selected galleries and museums in Britain and North America. Her paintings are in many collections worldwide and she regularly undertakes important commissions internationally.

WHAT IS GOUACHE?

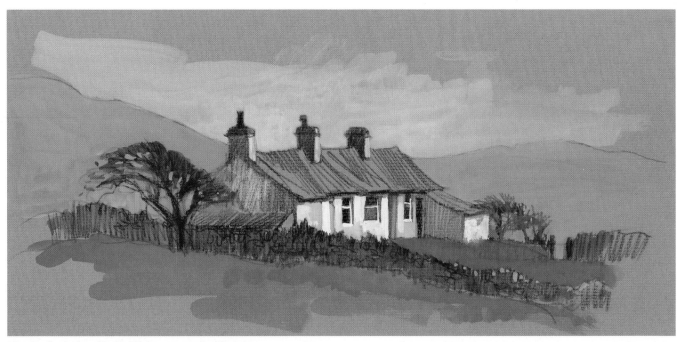

Fig. 3 *Cottages, North Wales*, gouache sketch

What is gouache? This is a question that I am frequently asked. Even the word itself has a mysterious ring to it, but the answer is really very simple. Gouache is an opaque watercolour medium of artists' quality. Sometimes referred to as body colour, it is liquid in form and contained in tubes. To be more precise, gouache is pigment, plus a binder (gum tragacanth) and white or, in some cases, it is a binder with a strong pigment that is dense enough to be opaque without the addition of white. It is a permanent medium but, as with all other media, some pigments have a greater degree of permanence than others, and manufacturers always indicate this in their lists. Daler-Rowney gouache colours have a high pigment content and possess a good body and covering power, and I have used them throughout the book.

Gouache is a most attractive and easy medium to use and it is gaining greatly in popularity with amateur painters. It is not a new medium to professional artists and designers and, in fact, has quite a long history. Often referred to as body colour, it was used by such painters as Dürer, Rubens, Van Dyck and Poussin. In the eighteenth and nineteenth centuries Chinese White was often added to transparent watercolour to make it opaque, and Turner used this 'gouache' very effectively on tinted paper. In more recent years, gouache has been used by, among others, Degas, Vuillard, Picasso, Matisse, Sutherland and Ben Shahn. Matisse created

some of his collages from good-quality paper painted with gouache, which produced the permanent, brilliant, flat colour he desired.

Not only has gouache been used for fine art painting techniques, it has also been developed for today's professional designers and is called Designers' Gouache. All the colours are intermixable and allow the designer to achieve a fine degree of colour matching, which reproduces well.

A compatible medium

One of the great advantages of using gouache is its compatibility with other painting media, which enables the artist to mix the media and produce some exciting images. For example, a painting can be made using pastel, watercolour, ink and gouache, and such a painting is referred to as 'mixed media'. My quick sketch (**fig. 3**), *Cottages, North Wales*, was made on a toned paper, using gouache and conté pencil.

Transparent watercolour can be made opaque by mixing it with white gouache. If you are a beginner or are accustomed to working with transparent colour, experimenting with the use of white added to watercolour will give you a good introduction to the characteristics of working in an opaque medium.

If you are an oil painter, you will probably instinctively take to painting with gouache because, although

6

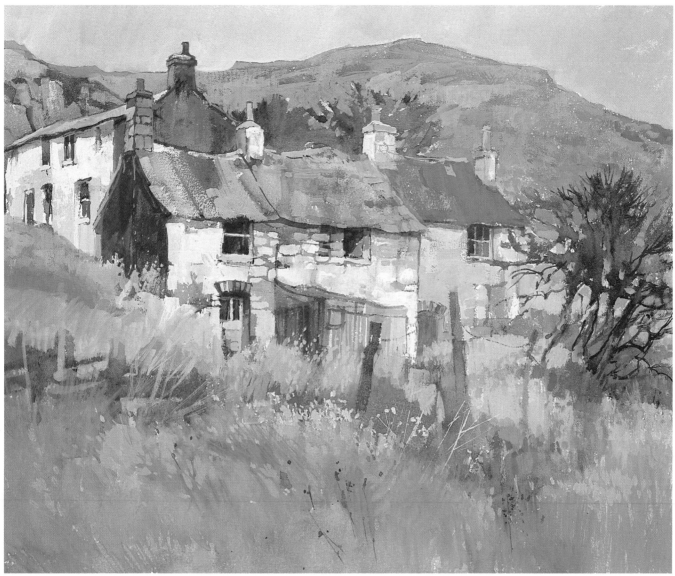

Fig. 4 *Pink Cottages, Wales*, 33 × 42 cm (13 × 16½ in)

it is a water-based medium, it can be used in a similar way to oil paint. *Pink Cottages* (**fig. 4**) demonstrates the similarity in technique to oil painting. I was concerned to show the light falling around the buildings, so I concentrated the brightest and lightest colours on this area using gouache paint fairly thickly. Any white pigment present in the manufacture of gouache colours reflects the light and helps to give a sparkle to the painting.

A versatile medium

Although gouache is a medium that is akin to oil painting, it can also be used in a similar way to wet-in-wet watercolour painting. Because gouache is a water-based medium, many different qualities of paint and transparency of colour can be achieved depending on the amount of water that is added. These different techniques of painting with gouache can be incorporated

within a single painting. Areas of wet-in-wet dilute colour can interplay with areas of a thick build-up of paint, and these variations can create visually interesting surface textures.

Judging the amount of water to add to gouache to gain the desired effect is a skill that you will learn with practice, and I recommend that you try the exercises on pages 16–17 to familiarize yourself with the 'feel' of the various consistencies of the paint.

Another great advantage of painting with gouache is that any grease-free paper or board can be used, and details of some of the many supports available are given on pages 12–13. Opaque paint can be used very effectively both on toned paper or board, covering it entirely in places and leaving it uncovered in other parts, and on a white support.

Gouache is a good medium for the beginner because it allows for alterations to be made as the work

7

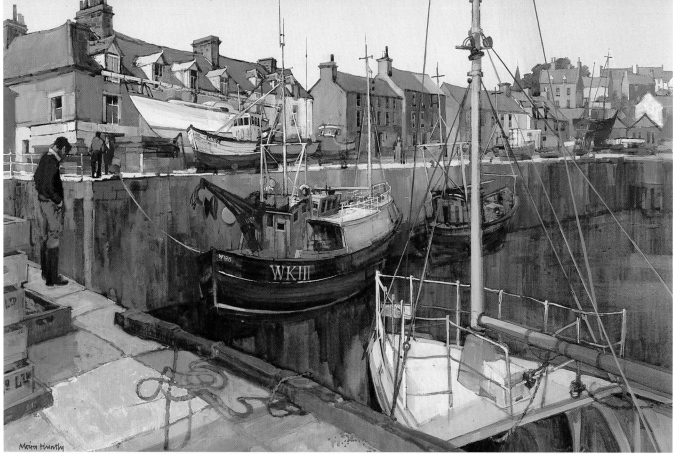

Fig. 5 *Wick Harbour, Caithness*, 55 × 75 cm (22 × 30 in)

progresses. We all make mistakes and it is comforting to know that a passage of paint is recoverable. To re-work an area of paint you can dampen it and lift it off with a moist brush before re-applying paint, or super-impose a thicker layer of gouache over a thin passage of paint. Either way, mistakes can be rectified and the painting can continue to develop.

Ideal for working outdoors

I never set out on a sketching trip without a few tubes of gouache and a plastic palette among my painting gear. It is an ideal medium for working outdoors and catch-ing fleeting effects quickly, and it dries rapidly without being adversely affected by the sun. On bright days, when the light reflected off a white piece of paper is blinding, I find it a boon to be able to work in gouache on a toned paper.

Finished paintings are easily transported in a folder, but take care not to allow anything to rub against the surface of the painting. This can cause the paint to become polished, giving the finished work an unpleasant shine.

Light tones can be painted over dark

Wick Harbour (**fig. 5**) illustrates many of the particular qualities and advantages of painting with gouache. I painted it in the studio from a conté pencil drawing made on the spot. I used a heavy watercolour paper and

started by painting washes of watercolour all over the paper. These washes provided a coloured background of Raw Sienna in the sky and Hooker's Green in the water, and were applied quickly with a large brush and without any attempt to describe the features. I then used diluted Burnt Umber gouache to draw the subject directly with a brush on top of the washes, not worrying if some of the brushwork flared into the damp colour.

The subject was gradually developed by painting the light areas with opaque gouache over the darker washes. Using gouache enables you to paint light tones over a dark ground, sometimes with a dry brush so that the ground shows through in places. The sky wash in this painting was light in tone and I painted a fairly even layer of cool pearly gouache all over it, allowing hints of warm Sienna to glow through the opaque paint. Opaque paint is particularly useful for painting light colours over dark-toned buildings and for details such as windowpanes, masts and ropes.

Effective use of a limited palette

Robin Hood's Bay, East Yorkshire (**fig. 6**) is another studio painting made on a white ground. There are sev-eral fishing villages on the Yorkshire coast that are attractive to painters as well as tourists. This one is built at the bottom of a very steep hill with a narrow street that twists and turns between the houses as it descends to the sea. I sat precariously balanced on a wall in order to draw the view I particularly wanted. I was interested

8

Fig. 6
Robin Hood's Bay, East Yorkshire,
48 × 35 cm
(19 × 14 in)

in the contrasts of bright sunlight and deep shade on the buildings, which together made a pleasing pattern of light and dark shapes. The drawing, which was quite detailed, was made with a black conté pencil.

The painting is a combination of very dilute transparent washes of gouache, milky washes of Permanent White, and areas of thick, opaque paint. First I tinted the paper all over with a mixed wash of Vermilion Red and Tangerine and then with washes of dilute Olive Green and a little Burnt Umber. The subject was drawn with a small brush and Burnt Sienna, and the shadows were strengthened with washes of Ultramarine. All the other colours in the painting were produced by intermixing this limited number of colours and also by introducing Permanent White to some of them. A limited palette is a good idea for a beginner, and it has also been popular with artists throughout history in creating harmony within a painting.

Gradually I added details and more light areas, such as the small, light building behind the two distant fig-

ures, which has a very important function in the painting. It attracts attention and draws the viewer along the street towards this light shape. It also suggests an invitation to walk around the corner to investigate the narrow, twisting hill beyond, an effect that is further emphasized by the two distant figures.

The rewards of gouache

The advantages of painting with gouache are that it has great opacity, it is quick drying and can give flat, even colour or soft, flaring effects, depending on what is required. Thick paint can be built up over thin, it can be mixed with watercolour or combined with other media. A variety of grounds may be used, and mistakes can be rectified. The immediacy of gouache makes it ideal for working outdoors, and it enables the artist to paint using oil techniques but without the smell of turpentine, to which some people are allergic. It is a versatile and rewarding medium.

WHAT EQUIPMENT DO YOU NEED?

It is best to start in a simple way and gradually extend your range of equipment, but you need to have the basics to make a successful painting.

Paints

I use Daler-Rowney's gouache paint and the names I have referred to throughout the book are Daler-Rowney colours. Their range of colours is considerable, comprising nearly 100 in total. With so much choice it is sometimes difficult for a beginner to decide on the colours to buy first, so I will suggest a basic palette to which you will gradually want to add more and increase the range for special purposes, such as flower painting.

Daler-Rowney's brilliant gouache paints offer some exciting prospects, and their brilliance is highly suited to graphic reproduction as well as fine art painting techniques. The very intense colours can, of course, be mixed with other colours to give more subtle hues. It is important to bear in mind that part of the range was specifically developed for the designer, so a few of the colours tend to be less permanent and some will stain and may bleed through subsequent layers of paint.

However, as with all media, the manufacturer classifies each colour to show clearly the degree of permanence and staining, thus giving guidance in the selection of colours to suit the artist's purpose. All colours in the range are fully intermixable, which allows the artist to achieve a fine degree of colour matching.

Many of the earth-coloured pigments in most manufacturers' ranges of gouache paint tend to be hotter in appearance than in other media. To allow for this, I often use Yellow Ochre when I want a rich warm yellow and Raw Sienna as an equivalent to the normal yellow ochre hue.

For my basic selection of colours I have included two different reds, blues and yellows, some neutral colours and, of course, white: they are Vermilion Red, Crimson, Ultramarine, Rowney Blue, Lemon Yellow, Raw Sienna, Lamp Black, Burnt Umber, Burnt Sienna and Permanent White. If you are going to be painting trees and flowers, add Process Magenta, Tangerine, Brilliant Yellow, Olive Green, Viridian Green and Cobalt Blue. Do bear in mind that the colours I have listed are only suggestions and that you can make substitutes if you prefer to include others.

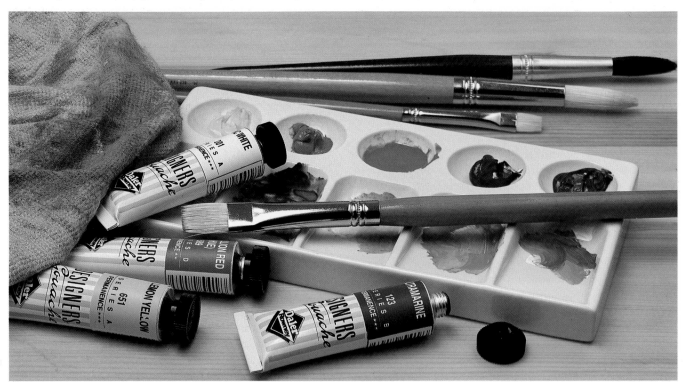

Fig. 7 A selection of materials for painting in gouache

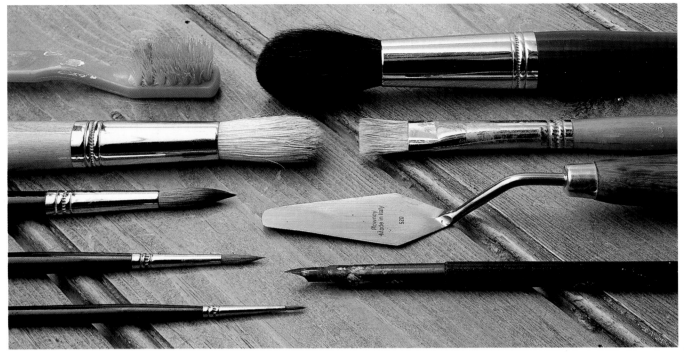

Fig. 8 Some of the many brushes, palette knives and dip pens suitable for use with gouache

Storing paint

In common with all water- or acrylic-based paints, when in contact with air gouache dries up with time and can harden in the tube. The length of time gouache colours last depends on how you treat them and how methodical you are when painting. I shudder when I see students squeezing a new tube in the middle, then leaving the cap off. No doubt they treat their toothpaste in the same way!

Paint will keep moist for a long period of time if air is excluded, so squeeze the tube from the base only, then replace the cap immediately afterwards. Do this each time you place paint on the palette and this good habit will quickly develop. When I have finished painting I store my tubes of gouache upside down, standing on their caps, in any suitable container. This encourages gravity to help in the exclusion of air.

Acrylising medium

This is a polymer resin which converts gouache paint into a flexible, water-resistant medium for use on acetate film or for overpainting without pick-up.

Palettes

Daler-Rowney make special china saucers and five-well china slant palettes, which I find ideal for gouache paint. They also make plastic palettes, which are light in weight and durable and therefore suitable for carrying when working out of doors.

Brushes, pens and palette knives

Fig. 8 shows a wide variety of brushes for gouache painting, from the finest Kolinsky sable to a large hog bristle brush. You can also apply gouache paint with a palette knife and a dip pen. The choice depends on the kind of painting that you are working on and the consistency of the paint, as well as on how much you can afford. Brushes can be very expensive, but I think it is worth having one or two really good sable brushes backed up by a range of less expensive ox hair, squirrel hair and hog bristle brushes.

There is a bewildering choice of brushes available, and a beginner could start by buying one small brush, one medium size and one large brush. We all have our favourite brushes and build up a collection over the years, and among my own favourites is a No. 7 Rowney Diana Round Kolinsky sable. A good sable brush, however large, can be dual purpose because it can be used both for details and, on its side, to brush in large areas. For extra fine details I use a No. 00 Rowney Diana Round Kolinsky sable brush and a No. 5 Rowney Series 34 Round, which is a more affordable, quality sable. I also like to paint with chisel-shaped brushes and use Rowney Series 55 ox-sable flat brushes, sizes 6 and 12. For washes and large paintings I use a Series 28 19 mm (¾ in) blended squirrel wash brush and a Series 66 extra large round squirrel hair mop brush. Among my hog bristle brushes I have Series 118 short flat, Nos. 6 and 8, and a Series 111 round No. 8.

Brushes should be rinsed thoroughly in cold water

11

straight after use and wiped carefully with a clean rag to remove excess moisture. Point the brush hairs back into shape between finger and thumb and store brushes upright in a jar.

Easels and boards

Buy a good easel if you can afford it. In the studio I use Daler-Rowney's Exeter radial easel, but if space is at a premium choose a table easel such as Rowney's Lincoln, which is sturdy and folds flat. **Fig. 9** shows some of my sketching equipment. For outdoor work the Warwick is a suitable metal folding sketching easel weighing just under 1.4 kg (3 lb). Thick hardboard is usually adequate for working on, but you need a heavier wooden drawing board if you want to stretch paper (see page 22).

Supports

One of the many advantages of gouache is that it is opaque and can therefore be painted on coloured paper or board. When the paint is applied thickly, the colour of the support is obliterated, and when the paint is diluted and washed on thinly, the colour of the support shows through and effectively modifies the colour applied. Areas of the paper or board can also be left unpainted so that the colour becomes part of the painting. Choose good quality pastel paper or mounting board, which will not fade when exposed to light.

Watercolour paper or board with not too rough a surface also makes a good support. When using white paper I find I can work more easily on it if I tint it first, by brushing it over with dilute gouache or transparent watercolour. A coloured ground is always interesting to work on and has the advantage of being less blinding if you are working out of doors in full sun.

There is no restriction on the size of support to work on, but a beginner would do well to start on approximately an A3 size. When I go out painting for the day, I often take sheets of heavy quality pastel paper (160 gsm), or pieces of mounting board cut to a variety of sizes and in various colours. I carry any finished paintings in a folder to protect the surface, which can easily become shiny if it is rubbed.

Fig. 10 shows some of the many papers and boards suitable for gouache painting. Watercolour paper can be obtained with a variety of surface textures and in different weights. Lightweight papers can be used but if they are very thin they will cockle, so it is best to stretch them on a board, as described on page 22. I usually use 160 gsm Ingres paper and not less than 290 gsm watercolour paper, but this is a matter of preference.

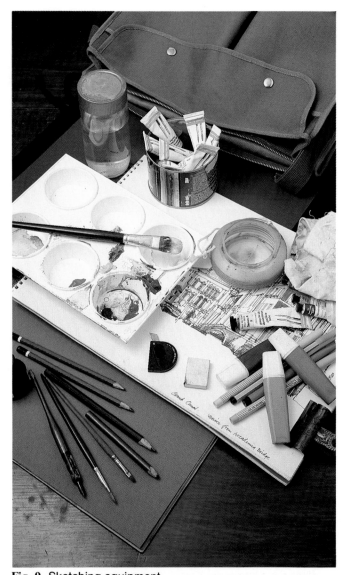

Fig. 9 Sketching equipment

Fig. 10 Key to supports, opposite
1 Whatman HP watercolour paper
2 Canford paper, Pearl Grey
3 Ingres paper, Slate Grey
4 Ingres paper, Sienna Brown
5 Bockingford watercolour paper
6 Ingres paper, Verona Green
7 Ingres paper, French Blue
8 Ingres paper, Tan
9 Whatman Not watercolour paper
10 Studland mounting board, Sepia
11 Cartridge paper
12 Studland mounting board, Blue Grey
13 Daler watercolour board (Saunders Waterford Not surface)

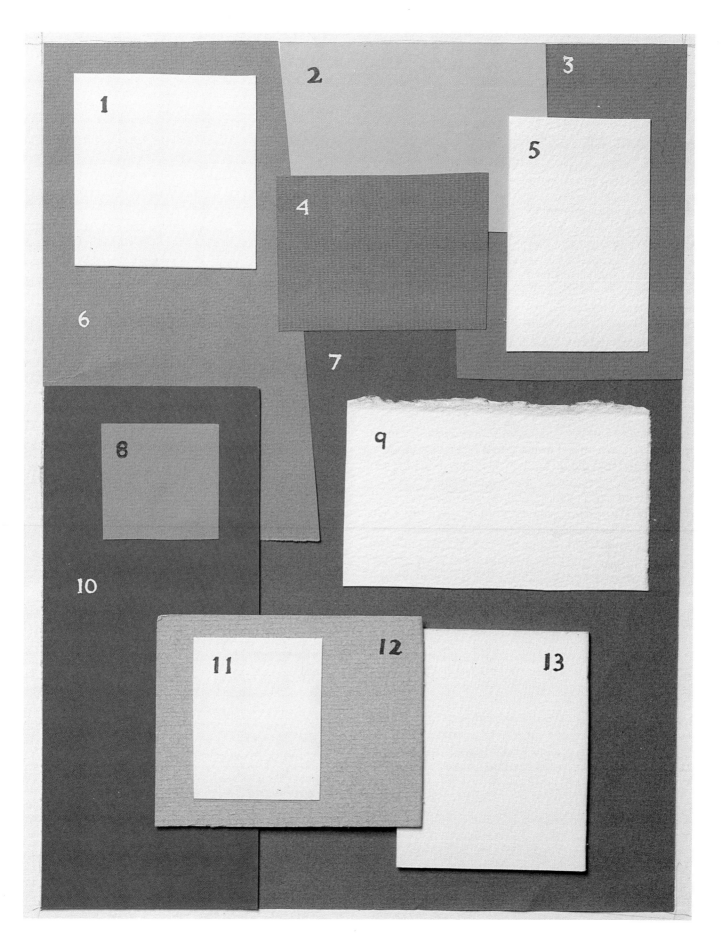

13

STARTING TO PAINT

Much of this information may be obvious to the experienced painter but it will help the beginner who is starting to paint in a new medium.

Setting out your palette

Don't put too much colour or too many different colours on to your palette to start with, but you will need plenty of Permanent White. When I set out my colours I tend to place the warm colours together and the cool colours together, and keep the black and white separate, as shown in **fig. 11**, but there are no rules about this. This happens to be the working practice that I have developed over the years and it enables me to know by habit where the colours are.

I use china palettes and saucers in the studio and a plastic palette for outdoor work because it is light to carry and durable. If you have a watercolour box don't be tempted to use the palette for gouache as the opaque paint may come into contact and adversely affect the transparent watercolours.

While you are painting you may find that some of the paint on the palette begins to dry. This is easily remedied by re-wetting the colour with your brush. If the mixing area becomes crowded or muddied it is important to clean off your palette. Sometimes I need to hold my palette under the tap and wash it off two or three times during the progress of a painting to ensure the colours do not become dirty.

Water pot and brushes

Choose a fairly large water pot so that brushes can be well rinsed. You will find that the water quickly colours and becomes opaque with the presence of so much white pigment, and it is necessary to change the water frequently to prevent it becoming muddy.

The range of brushes for painting with gouache is vast, so, to start with, choose a brush with which you are comfortable but preferably one that is not too small, for instance, a No. 6 or 7.

Adding water to gouache

Gouache is a very versatile watercolour medium, because it can be both opaque and transparent depending on the amount of water that is added to it. With a large amount of water the paint becomes transparent, whereas with a very small amount the paint

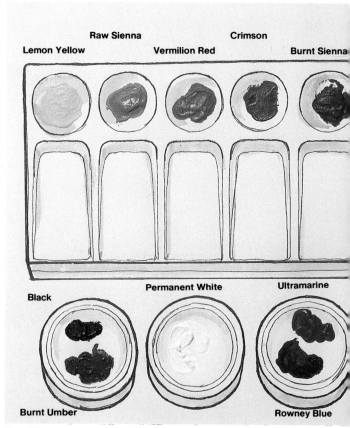

Fig. 11

retains its opacity. Gouache used straight from the tube, without any water, is totally opaque, but if it is applied too thickly, it may crack as it dries and drop off the surface. Impasto effects can be achieved without cracking if you add acrylising medium to the paint (see page 63). However, to begin with you should try to make gouache smooth and free flowing, and only experience will teach you how much or how little water to use in the mix. Achieving the required consistency comes with practice, so experiment with different amounts of water.

I start by wetting the brush, then add water to the paint a little at a time until it flows smoothly and has the consistency of cream. For wash effects I start by putting some water in a saucer, then gradually add gouache until I achieve the desired depth of colour.

Gouache can sometimes be deceptive and dry with a slightly different appearance from that of the colour you have mixed on your palette, depending on how much water has been used and how much white or dark

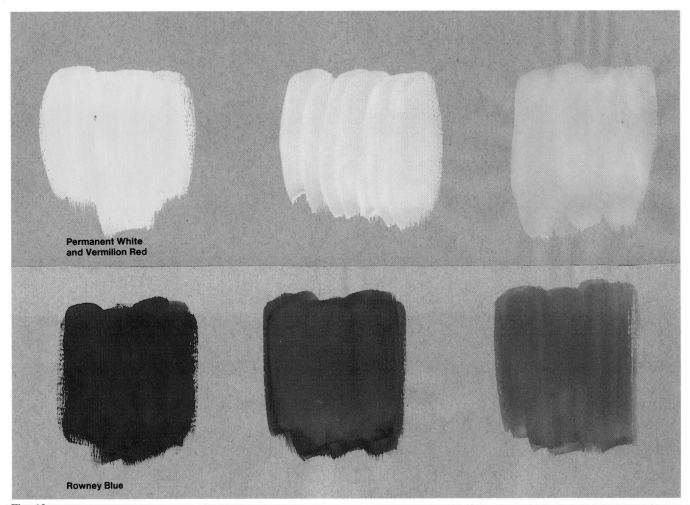

Permanent White
and Vermilion Red

Rowney Blue

Fig. 12

pigment the colour possesses. As a general rule, the less water you use the less change occurs.

Fig. 12 shows how different amounts of water added to gouache can change the appearance of the colour. I chose two colours – pink, which is made up of Permanent White and a small amount of Vermilion Red, and Rowney Blue – and painted them on blue-grey paper. You will see that the light pink colour seems to become darker with more water, and the dark blue appears to become lighter with more water. This is because the pink becomes less opaque as more water is added and so you can see more of the blue-grey paper beneath, especially on the pink patch on the right which has the most water. The Rowney Blue patch on the left has very little water and is a solid dark tone. The central blue patch has more water and is less intense, and the blue patch on the right is the result of using very dilute paint. This patch appears lighter in tone because the blue-grey paper, which is paler than the paint, shows through. You will see from this exercise how gouache colours vary not only depending on the amount of water that is added but also on the colour of the support used and on the tone of the paint.

Overpainting

As gouache is a water-based medium it is therefore water-soluble. In practice, this means that if you paint one layer over another, the under layer tends to dissolve. However, it is possible to overpaint by applying a thick layer over thin transparent paint. The first layer will not be disturbed because the thick paint has less water in the mix.

Try experimenting to discover for yourself what happens when overpainting with different consistencies of gouache. Apply some small patches of very thick colour, allow them to dry, then overpaint them with varying dilutions of paint. You should also try painting thick paint over dilute paint.

Another method of painting one layer on top of another is with the aid of Daler-Rowney Acrylising Medium. When added to gouache paint it makes the medium water-resistant, enabling you to overpaint without dissolving and picking up the first layer. You will find further information on the technique of overpainting with the use of acrylising medium on page 63.

15

HOW MUCH WATER?

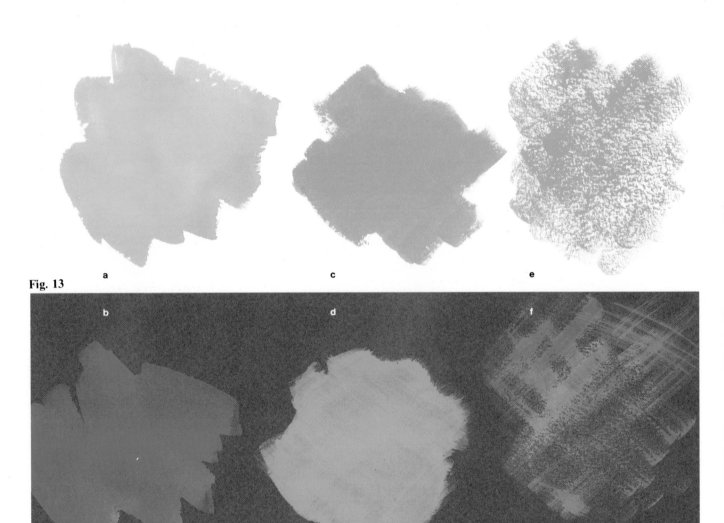

Fig. 13

The amount of water mixed with gouache has a great influence on the tone of the colour and the effectiveness of its cover on the painting ground. I have painted a few exercises to illustrate these points.

In **fig. 13a** I painted a dilute wash of Tangerine on to white watercolour paper, and it looks quite transparent because I used plenty of water. **Fig. 13b** shows an identical dilute wash, this time brushed on to a dark-toned support. Although the gouache is very dilute it retains a surprising amount of covering power on dark paper.

In **figs. 13c** and **13d** I have repeated these processes but I used less water to mix the gouache to a creamy consistency, which has produced a colour of greater intensity and covering power on the paper. Notice that by applying thicker paint the dark paper is completely

obliterated and that, although the paint mixture is identical, it appears lighter on the dark paper than on the white paper. So remember that paint will always appear lighter when painted on dark paper – it is an optical illusion. For the next two exercises, in **figs. 13e** and **13f**, I have used hardly any water so that the paint is thick and dragged across the paper to give a 'dry brush' effect with the paper breaking through.

Wet-in-wet techniques

The exercises in **fig. 13** were painted on dry paper and they have dried as hard-edged shapes. Very often we wish to paint soft edges, for example in clouds, or to create soft drifts of colour within a first wash.

16

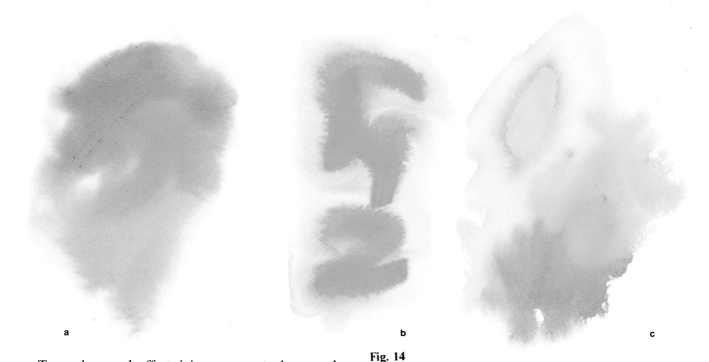

a b c

Fig. 14

d

To produce such effects it is necessary to dampen the paper with clean water and then brush the paint on to the damp surface. The paint will spread and diffuse in a fascinating way and give delightful soft edges. The degree of dampness in the paper and the amount of water used in mixing the paint have a considerable effect on the softness of edge and the spread of paint. Practice will help you to understand and know how to control these effects.

Try the following exercises, which I put together just after I had completed a large flower painting. The brilliance of the gouache medium is ideal for capturing the pure, vibrant colours of flowers, and I thought the exercises would look attractive if I used two of my flower colours for them: Tangerine and Process Magenta. This does not mean that you should buy these particular tubes of colour in order to do the exercises. You can use any colour combination.

For **fig. 14a** I dampened a piece of watercolour paper with a brushful of clean water and painted dilute Process Magenta into it. The colour diffused into the water, creating soft edges. While the colour was still damp I brushed a little extra Process Magenta into the top area of the patch, which produced a slightly darker, soft-edged blush of colour. In **fig. 14b** I started in the same way as in fig. 14a but this time used Tangerine and brushed fairly thick paint into the centre of the patch. This produced a darker shape within the first wash but still with soft edges.

Fig. 14c was started by painting dilute Tangerine on to damp watercolour paper. I then immediately painted Process Magenta into it, which merged softly into the wet Tangerine colour. In **fig. 14d** I painted brush strokes of dilute Tangerine, Process Magenta and Permanent White on to wet dark paper. The colours diffused into each other to give interesting effects.

BASIC TECHNIQUES

In these exercises I show a few basic ways of working with gouache. The patches of colour demonstrate the techniques used to paint each flower motif.

Applying colour

In **fig. 15a** I painted Process Magenta on dry watercolour paper, then allowed the paint to dry before brushing dilute Permanent White on top. The white has mixed with the Process Magenta and become a pale pink. I used this technique for **fig. 15b**, painting the flower with Process Magenta followed by dilute Permanent White over part of the petals and leaves.

Fig. 16a shows Process Magenta applied over an almost dry wash of Tangerine and extended on to the white paper. Notice how the rose colour becomes more of a red as it mixes slightly with the Tangerine. In **fig. 16b** I painted Process Magenta on top of Tangerine petals and again the rose has mixed slightly with the Tangerine. For the centre of the flower I painted Process Magenta directly on to white paper. The leaves are a reversal: here I painted Tangerine veins, which have picked up a little of the rose colour beneath.

In **fig. 17a** I painted Process Magenta of medium consistency on heavy watercolour paper and allowed it to dry, then applied Permanent White on top with a dry brush. I used very little water with the white so it has covered the rose colour without dissolving much of it, and there is only a hint of pink in the white. The motif in **fig. 17b** was painted in the same way, using a dry brush and Permanent White over Process Magenta.

Painting wet in wet

In **fig. 18a** I painted Process Magenta on dark-toned paper, then dropped a blob of dilute Permanent White into it before it had fully dried. The white paint has flared outwards into the damp rose colour. In **fig. 18b** I used the same wet-in-wet technique for the flower and leaves. The white flower centre was painted directly on the toned paper after the Process Magenta was dry.

Fig. 19a also demonstrates the wet-in-wet technique but this time I used thicker paint. I started with Tangerine, then gradually worked Process Magenta into it before it dried. The two colours merge together. For the flower motif in **fig. 19b** I used the same technique.

In **fig. 20a** I made a graded wash using thick paint on dark paper. I started with Tangerine and worked downwards, then I painted Process Magenta from the bot-

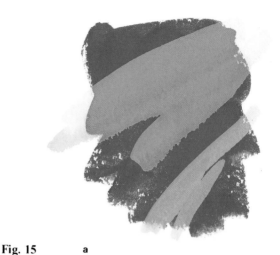

Fig. 15 a

Fig. 17 a

Fig. 19 a

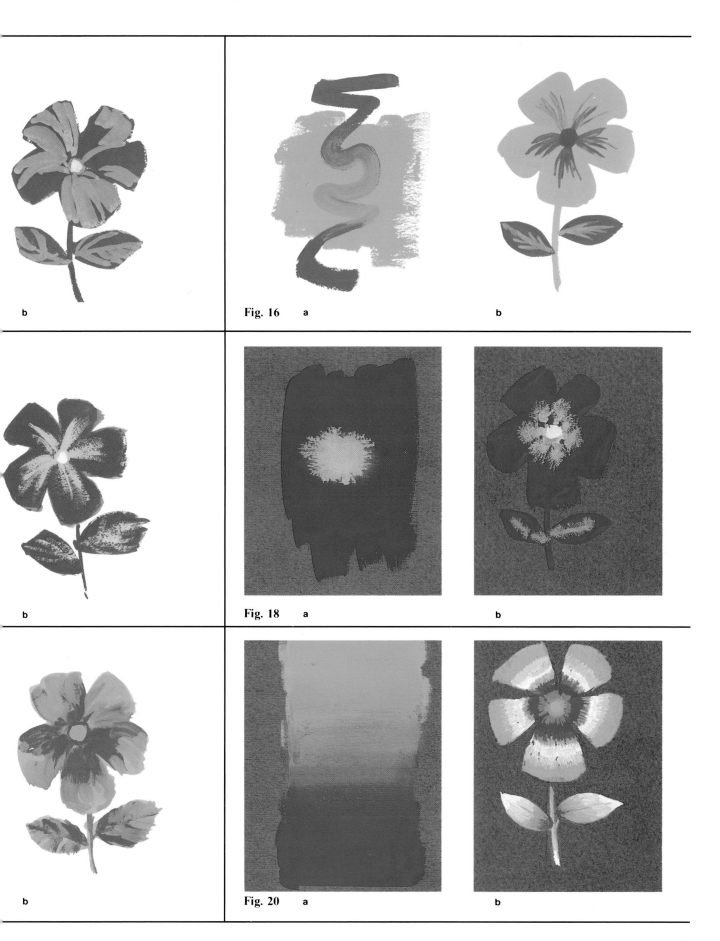

b

Fig. 16　a

b

b

Fig. 18　a

b

b

Fig. 20　a

b

19

tom upwards and brushed it into the Tangerine before it dried. **Fig. 20b** shows circles of Tangerine, Process Magenta and Permanent White worked in while wet so that each colour merges with its neighbour.

Dry-brush application

So far we have been dealing mainly with basic application of paint to discover how it behaves under various conditions of wetness. Now we start to look at some 'graphic' possibilities. **Fig. 21a** shows dry brush marks made with a flat No. 8 bristle brush and Red Earth paint used straight from the tube. The bristles in the brush create a texture in the paint resembling the grain in timber or strands of hair. In **fig. 21b** I made vertical strokes with the same colour and brush to depict bricks.

Drawing patterns

Fig. 22a illustrates patterns on a smooth paper, using mainly drawing techniques. The fine Red Earth lines were made with a No. 0 sable brush, and the finer black lines were made with a dip pen and Jet Black gouache mixed with enough water to allow it to flow from the pen nib. I used a brush loaded with gouache to fill the nib. **Fig. 22b** shows a development of this exercise. A very dilute wash of Permanent White was painted on black paper and allowed to dry. I then painted Red Earth lines with a No. 0 sable brush and used the pen for the black lines and dots.

For **fig. 23a** I again used the No. 0 sable brush but this time I drew on wet paper. The line is much thicker than in fig. 22a because the paint has spread into the water on the paper surface. The same technique was used in **fig. 23b** but this time I painted with Permanent White and Red Earth on damp black paper.

In **fig. 24a** I spattered Red Earth gouache on to watercolour paper by dragging a knife across a toothbrush. In **fig. 24b** I spattered Red Earth and Permanent White on to black paper, and when it was dry I added the bricks drawn with a fine brush and Permanent White and Red Earth.

Fig. 25a shows a technique of drawing by scratching paint away with a palette knife while it is damp, to reveal the paper beneath. In **fig. 25b** the bricks look as if they have been drawn with charcoal but, in fact, they were scratched through Red Earth paint to reveal the black paper beneath.

I started **fig. 26** by outlining bricks in Red Earth and Jet Black with a large brush, then filling in a few with solid paint. When these were dry, I applied a brushful of clean water across the bricks. This picked up some colour, softened the outlines and deposited a wash of mixed red and black over the paper.

Fig. 27 shows a combination of wet painted areas and dry brush techniques using fine and bristle brushes.

Fig. 21 a

Fig. 23 a

Fig. 25 a

20

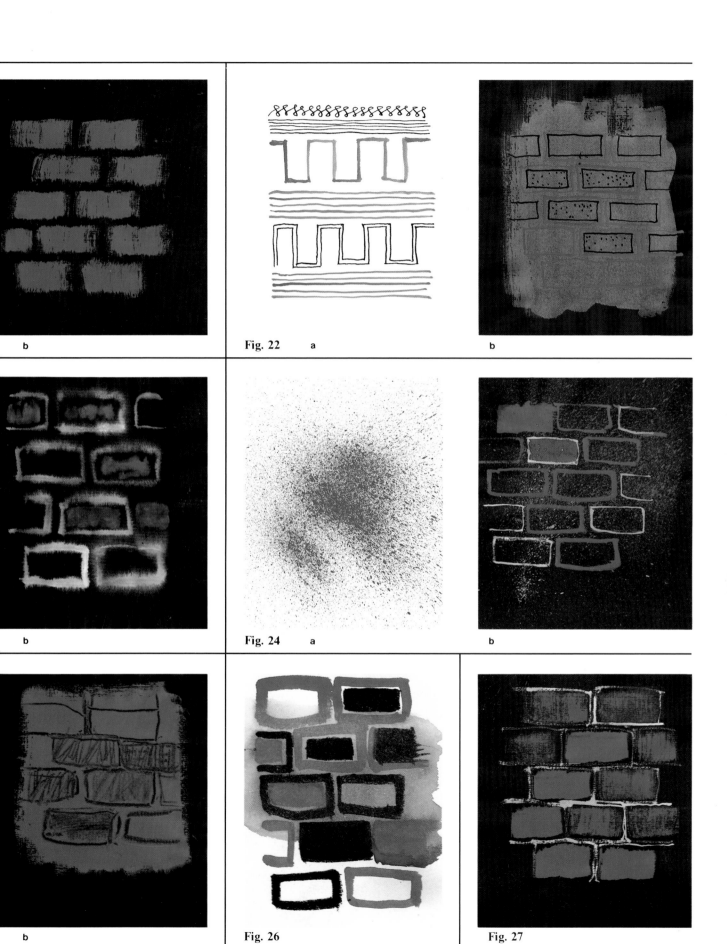

b

Fig. 22 a b

b

Fig. 24 a b

b **Fig. 26** **Fig. 27**

SIMPLE EXERCISES

Stretching paper

For the following exercises I used a variety of paper and board to show the different effects that can be achieved. I used a heavy watercolour paper, Ingres (pastel) paper and Ingres mounting board. Lightweight watercolour and Ingres papers tend to cockle badly when wet, making them difficult to work on, so they must be stretched first. To do this, soak the paper in cold water, leave for a few minutes, then place on a stout board. Carefully blot surplus water from the edge of the paper with a clean rag and stick down the sides of the paper with gummed paper strip. The paper will dry taut and ready to work on.

Skies

I chose a subject that does not require much drawing, so that you can concentrate on painting. I have drawn a low landfall to allow plenty of room for painting in the sky. Try the exercises on fairly small pieces of paper if you wish, approximately 13 × 18 cm (5 × 7 in) or 19 × 25 cm (7½ × 10 in).

Fig. 28 is a gentle sky exercise with a graded wash on Blue-Grey Ingres paper. I began by outlining the landscape with a brown-coloured pencil. I then mixed the pale blue sky colour by adding a small amount of Rowney Blue to Permanent White and enough water to make it flow.

When you are mixing a pale colour it is important to start with the white and gradually add small amounts of colour to it. Coloured pigment is powerful, so you require only a very small amount to tint white, whereas it would take a great deal of white to lighten a small quantity of strong colour to the same pale tint.

I started painting the sky at the top of the paper using a soft No. 6 sable brush. I painted with horizontal brush strokes, gradually adding more white to the mixture as I worked downwards, ending with the palest blue on the horizon, which creates an impression of distance. When you are trying this exercise you may find that you need to add a touch of extra water to help the paint to flow.

For **fig. 29** I used 290 gsm Whatman watercolour paper, which has a textured surface that creates broken effects on the edge of brush strokes. This exercise is again a graded sky painted with the same colour mix as in fig. 28, but this time I used a No. 6 oil painter's bristle brush and applied the colour with random brush

Fig. 28

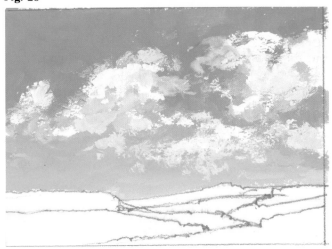

Fig. 29

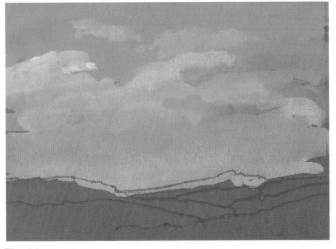

Fig. 30

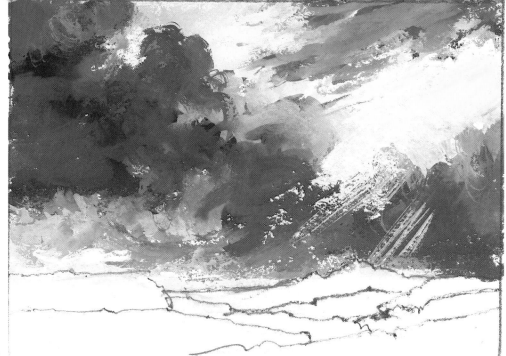

Fig. 31

strokes, leaving patches of white paper ready for the clouds. I painted the undersides of the clouds with fairly thick Cool Grey 1, overlapping slightly on to the blue sky, and the top of the clouds with thick Permanent White. The stiffness of the bristle brush helped to create the broken cloud effects.

Fig. 30 is a graded sky painted with a soft brush on to warm-coloured Sienna Brown Ingres paper. This time I added more water to the colour mix than for the previous two exercises and I dampened the paper with clean water before starting to paint, which enabled me to use a wet-in-wet technique. Once again I lightened the blue slightly as I approached the horizon and then quickly painted a few clouds with dilute Permanent White before the first wash was dry. The white dissolved slightly into the blue, giving the clouds soft-edged effects. Where the paint is very thin, the Sienna Brown paper shows through and creates the impression of a third colour.

The stormy sky in fig. 31 was painted with a bristle brush on Whatman watercolour paper. The light areas of the sky were painted first, using a moderately dilute mixture of Permanent White and a little Lemon Yellow. The colours used for the storm clouds were mixtures of Ultramarine and Burnt Sienna, and Ultramarine and Raw Umber in varying proportions, sometimes with additional Permanent White to lighten the tone. This top layer of paint was fairly thick and gave a broken edge to the clouds.

For fig. 32 I used a Deep Stone Ingres board and once again started by painting the sky with a mixture of Permanent White and a little Lemon Yellow and a soft brush. Some of the paint is very dilute so that the tone of the board shows through; in other areas the paint was of a thicker, creamy consistency. The colours used were Ultramarine, Raw Umber and Permanent White. Notice that the clouds become smaller as they approach the horizon, creating a feeling of distance.

Fig. 32

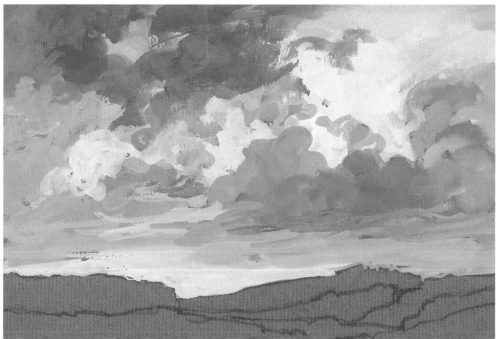

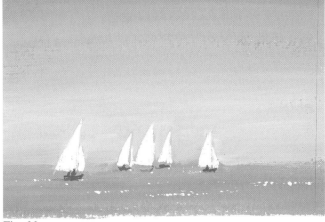

Fig. 33

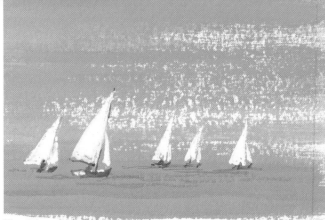

Fig. 34

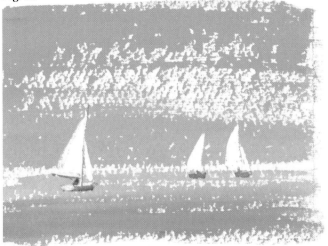

Fig. 35

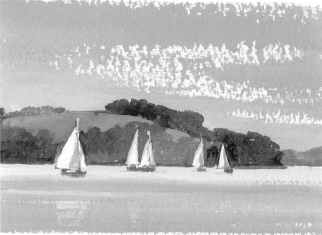

Fig. 36

Fig. 37 Detail of **fig. 36**, first stage

Fig. 38 Detail of **fig. 36**, second stage

Sailing boats

I enjoy making simple little paintings such as these, consisting of few features and painted in distinct stages. These small sailing boat works measure only 9 × 13 cm (3½ × 5 in).

I have used different types of watercolour paper for each of the sailing boat exercises to show how the final effect of a painting varies depending on the support used. Paint applied to a rough surface will have a dragged effect and give a textured finish. A paper that is only slightly rough will have less effect on the resulting paint surface, and a smooth paper will give very little texture and produce a more sensitive, 'finished' quality.

In **fig. 33** I brushed pale blue, made with Permanent White mixed with a small amount of Cobalt Blue, on to a fairly smooth watercolour paper. A smooth or hot-pressed paper enables a graded wash to be laid more easily than on a textured surface. I gradually lightened the wash towards the horizon, then darkened the tone for the sea area towards the bottom of the paper. When the wash was dry I painted the sailing boats on top with thick Permanent White and touches of Burnt Umber and Neutral Grey 1 for the hulls, then added a few tiny white flecks with a very fine No. 0 sable brush to give sparkle to the water.

Fig. 34 is a repetition of this sequence, this time painted on a medium-textured watercolour paper. I allowed some of the texture to break through in the sky by leaving the paint in the brush to become dry and painting fairly quickly so that the brush strokes almost glanced across the paper surface. Then I recharged my brush and painted a more solid wash, which covered the paper completely towards the bottom.

In **fig. 35** I followed the same sequence but changed the colour mix by adding Rowney Blue to Permanent White and used a very rough, heavily-textured watercolour paper. The coarse white surface breaks through the paint in a very pronounced way, which gives a noticeable sparkle in the sky and water.

In **fig. 36** I have taken the subject further by adding

the tree-clad land. I started by drawing a pencil outline of the land on a medium-textured watercolour paper. Then I painted the sky and sea using a mixture of Cobalt Blue and Cool Grey 1 and followed the same process as in fig. 34, allowing the texture of the paper to break through and give sparkle to the sky. I added a little more water to the pale blue colour to give the sea a smoother effect, and before the wash had dried I worked in some Permanent White near the shoreline to cast light on the water.

Fig. 37 is a detail of fig. 36, showing the first stage of painting the land. I used a moderately dilute mixture of Viridian Green and Burnt Umber to paint the whole area, then dabbed over it with the brush to suggest trees. When this had dried, I painted the field (fig. 38) with a mixture of Lemon Yellow and a little Permanent White, and the dark layer of paint beneath partly dissolved and mixed into the pale yellow, resulting in a pleasantly soft green.

Houses

This little exercise was made on a moderately textured watercolour paper and the painting was only 11 cm (4½ in) square, but you may prefer to work larger.

First stage (fig. 39) I started by drawing a simple pencil outline and then brushed dilute Cobalt Blue into the sky area, not worrying about painting over the pencil lines. While the paint was wet I started to add the clouds, using slightly dilute Permanent White, which ran into the blue and gave a soft edge to the clouds.

Second stage (fig. 40) I added a few more clouds with dilute Permanent White and then established the areas of shadow on the buildings with a dilute wash of Cobalt Blue and the warm, sunny parts with dilute Brilliant Yellow. I painted the roofs with Burnt Umber, then darkened the colour with some Lamp Black to paint the windows and doors as simple rectangles.

Finished stage (fig. 41) For this I used the gouache thickly with hardly any water added. I dragged Permanent White over the building on the left, allowing some of the yellow underpainting to break through and keep the impression of warm sunlight. I also used Permanent White to pick up the light on some of the chimneys and the wall on the right. A mixture of Permanent White with a little Brilliant Yellow and Vermilion Red was painted thickly on to the centre building and mixtures of Copper Brown, Raw Umber and Burnt Umber were dragged over the roofs. Lastly, I used a fine No. 0 sable brush to paint the details on the windows with Permanent White and the chimneys with the orange mixture used for the centre building and Burnt Umber mixed with a little Lamp Black.

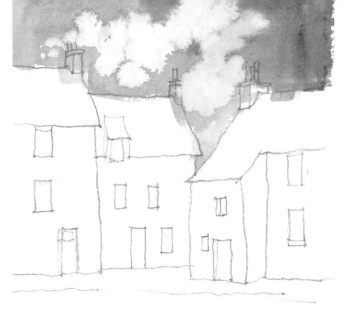

Fig. 39 First stage

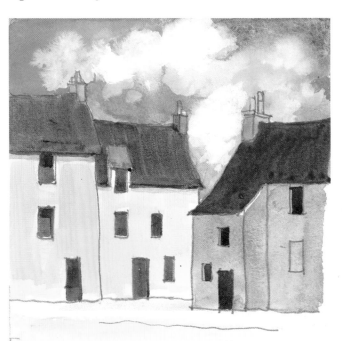

Fig. 40 Second stage

Fig. 41 Finished stage

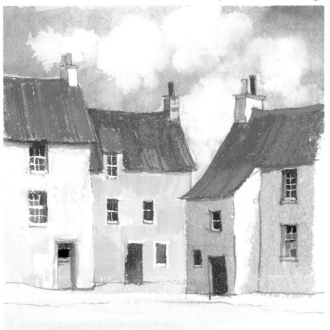

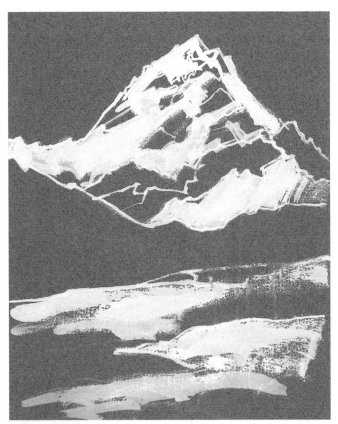

Fig. 42 First stage

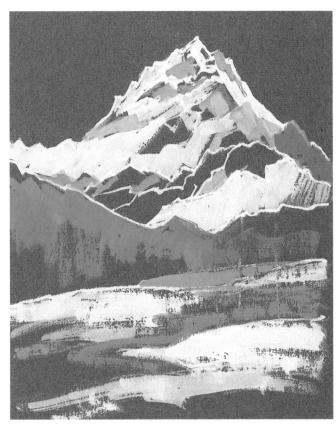

Fig. 43 Second stage

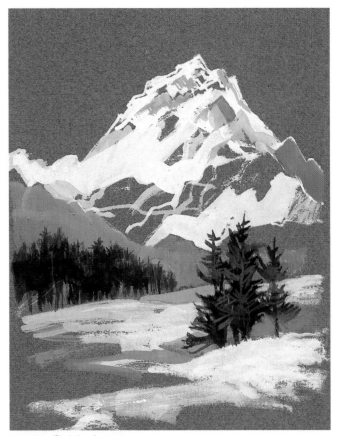

Fig. 44 Finished stage

Mountains

This exercise shows the effect achieved by using opaque light-toned gouache on a dark-toned paper and leaving some areas unpainted so that the toned paper becomes incorporated into the painting. I wanted a cool-coloured paper to enhance the icy mountain scene, so I chose French Blue Ingres paper.

First stage (fig. 42) I drew directly on to the paper with a No. 2 sable brush and Permanent White, but you could make a preliminary light pencil outline as a guide if you prefer. For the snow I painted some large areas of fairly thick Permanent White with a No. 5 soft brush. When I had only a little paint left in the brush and it was beginning to dry, I dragged it over part of the foreground to give patches of broken textured snow.

Second stage (fig. 43) I added a little Ultramarine to Permanent White to make the pale blue for the areas of snow in shadow. Some of this mixture was painted directly on to the paper and some brushed on to previously painted areas. Where the blue has been painted over the white it has mixed with it slightly and dried as a paler tone of blue.

Finished stage (fig. 44) I superimposed a few winter trees on the scene, using a smaller, No. 2, brush and a

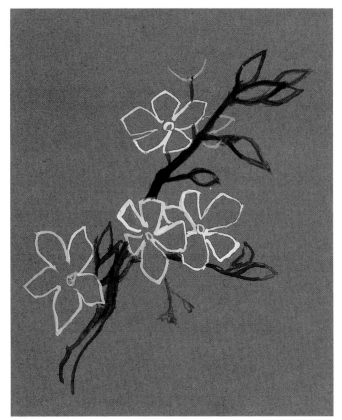

Fig. 45 First stage

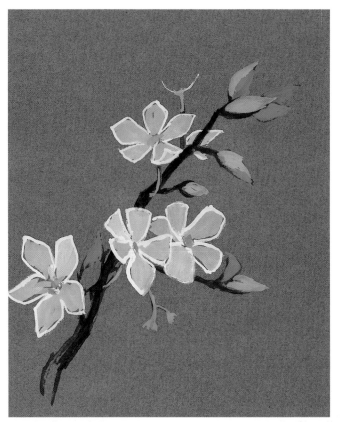

Fig. 46 Second stage

mixture of Burnt Umber and Ultramarine, then touched up and refined details, such as the tops of the distant trees, with a very small, No. 0, sable.

Blossom

This little study of blossom from the damson tree is painted on Slate Grey Ingres paper.

First stage (fig. 45) I started by painting the branch and leaves with a No. 2 sable brush and a mixture of dilute Burnt Umber and Olive Green. Then I outlined the flowers with a small No. 1 sable and dilute Permanent White.

Second stage (fig. 46) I painted the flowers with very dilute Permanent White, which allows the dark paper to filter through and give the petals a translucent quality. The leaves were painted with thicker mixtures of Lemon Yellow, Olive Green and Permanent White in varying proportions.

Finished stage (fig. 47) I used thick Permanent White gouache with hardly any water to paint the petals that caught the light. The petals that are in the shade are left untouched. Finally, I added details with a very fine, No. 000, sable brush and Copper Brown and a mixture of Raw Sienna and Permanent White.

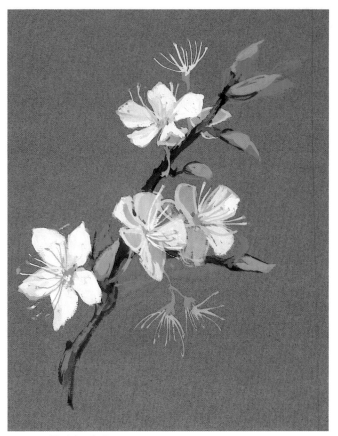

Fig. 47 Finished stage

LANDSCAPE IN RED, WHITE AND BLUE

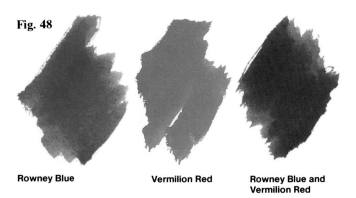

Fig. 48

Rowney Blue Vermilion Red Rowney Blue and Vermilion Red

Limiting ourselves to working with very few colours is a good discipline, and I thought that it would be fun to try painting a landscape in red, white and blue.

This sounds a surprising choice of colours for a landscape but some interesting results can be obtained, depending on which red and blue you choose. Ultramarine and Crimson would be too pretty and purple for my taste, but you may like to try them. I prefer to team a bright red with a blue that leans towards green, so I chose Vermilion Red and Rowney Blue (**fig. 48**).

Mixing colours

Dark rich colours can be achieved by mixing these reds and blues together, and the addition of Permanent White in different amounts extends the range to include some soft pearly colours and subtle greys (**fig. 49**). Many variations of colour can be obtained by altering the proportion of red to blue in each mix. Cool colours are made by using a greater proportion of blue than red, and warm browns and pinky mauves can be achieved with a greater proportion of red.

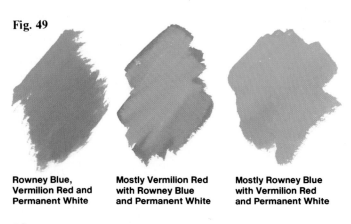

Fig. 49

Rowney Blue, Vermilion Red and Permanent White Mostly Vermilion Red with Rowney Blue and Permanent White Mostly Rowney Blue with Vermilion Red and Permanent White

Different interpretations

Fig. 50 shows the pencil outline that I used for each painting. Exactly the same colours have been used for the paintings but the general effect and mood of each are different, caused by the choice of support and variations in the proportion of colour in the mix.

Fig. 51 is painted on Whatman watercolour paper. The rough surface breaks through some of the brushwork and gives an overall sparkle to the painting. I wanted to convey a feeling of light and vitality, with sparkling water, scudding clouds and colourful contrasts on the mountains. In places, craggy mountain edges and tree lines are dark and sharply silhouetted against a lighter background. However, the general colour emphasis emanates from the simple blue sky, which is reflected in the water.

In **fig. 52** I used Deep Stone Ingres board and painted with very dilute gouache in some areas, which allows the dark ground to show through and lower the tones. The lightest parts are painted more thickly so that the opaque quality of the gouache covers the dark support. The effects are more subtle than in the previous painting, with very sensitive changes of colour on the mountains and foreground. The water is not so bright and the impression is of the early morning with a pink sky gradually lightening and the subdued features of the landscape just beginning to appear in the pearly light. By keeping the choice of colour subtle and the tonal contrasts very gentle, the effect of light in the sky above the mountain tops is heightened.

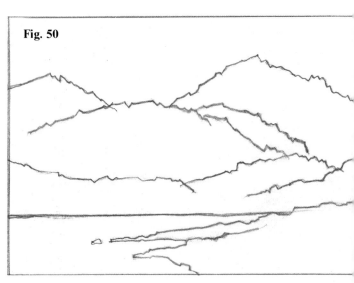

Fig. 50

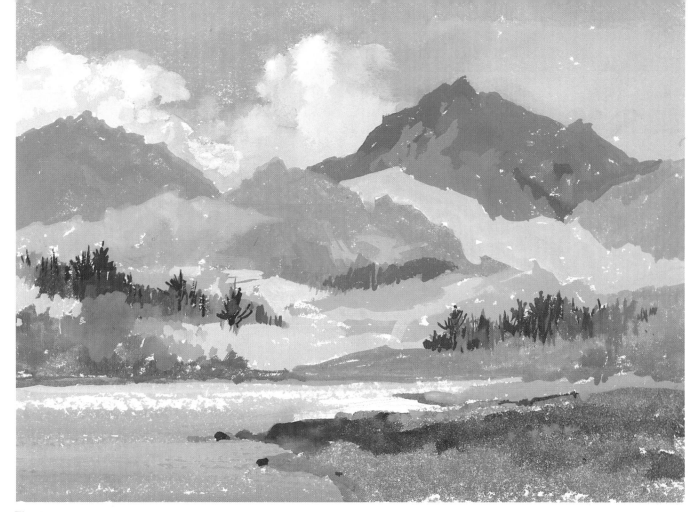

Fig. 51 above and **fig. 52** below

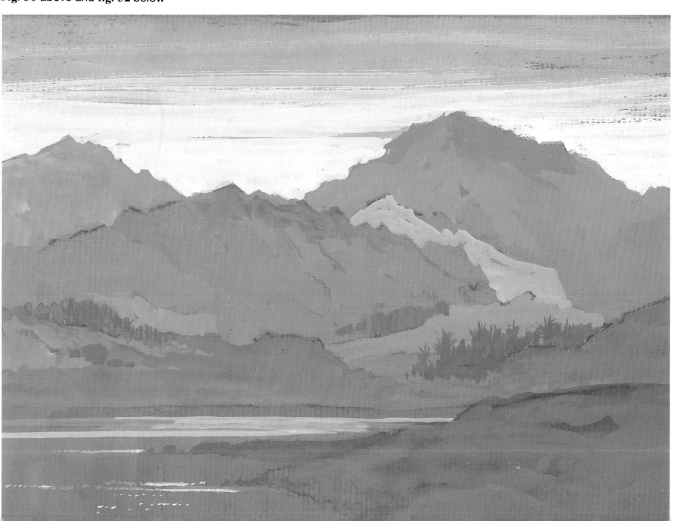

MIXING GREENS

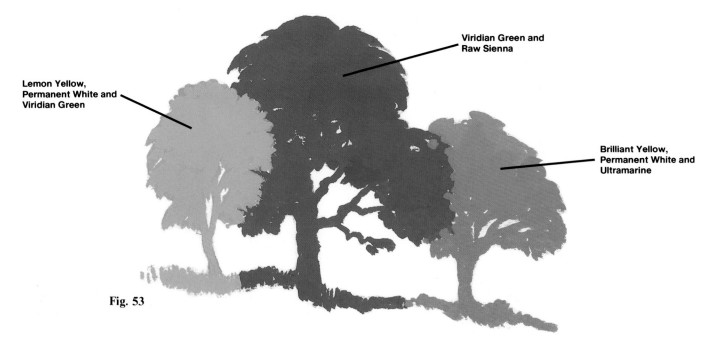

Viridian Green and Raw Sienna

Lemon Yellow, Permanent White and Viridian Green

Brilliant Yellow, Permanent White and Ultramarine

Fig. 53

We have already seen the effects that can be achieved using different-coloured supports for gouache painting. Once again we are going to vary the supports used but this time concentrate on painting with just one colour – green – and explore some of the tones that can be mixed.

I have used some simple tree silhouettes for these two exercises in mixing greens and I have repeated each of them on toned papers to show some surprising effects. As you will realize by now, a colour painted on a dark support looks very different from one painted on a white or light-coloured support.

In **fig. 53** the simple silhouetted trees are painted on white paper using mixtures of Lemon Yellow, Permanent White and a touch of Viridian Green for the light green tree on the left; Viridian Green and Raw Sienna for the dark middle tree; and Brilliant Yellow, Permanent White and Ultramarine for the grey-green tree on the right. In **fig. 54** I painted exactly the same colour mixtures on Tan Ingres paper. The light green

Fig. 54

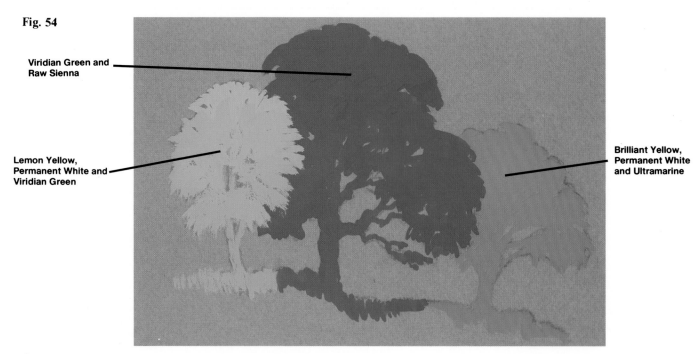

Viridian Green and Raw Sienna

Lemon Yellow, Permanent White and Viridian Green

Brilliant Yellow, Permanent White and Ultramarine

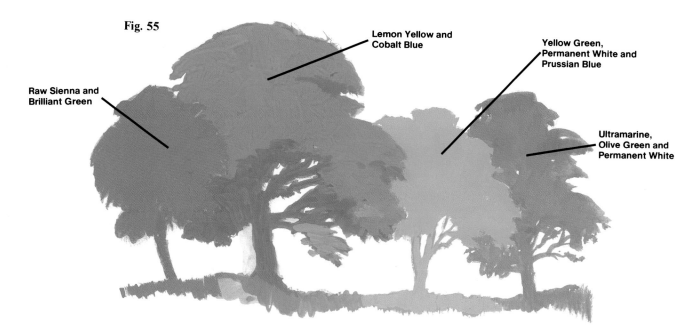

Fig. 55

Raw Sienna and
Brilliant Green

Lemon Yellow and
Cobalt Blue

Yellow Green,
Permanent White and
Prussian Blue

Ultramarine,
Olive Green and
Permanent White

seems lighter than on the white background, the dark green is not so contrasty and the grey-green merges softly with the Tan paper.

In **fig. 55** I painted the group of four trees on white paper, then repeated them on Deep Stone Ingres paper in **fig. 56**. The greens were made with Raw Sienna and Brilliant Green for the tree on the left, Lemon Yellow and Cobalt Blue in varying proportions for the large tree, Yellow Green, Permanent White and a little Prussian Blue for the light tree, and Ultramarine, Olive Green and Permanent White for the blue-grey tree on

the right. Again, there is a marked difference in the effects of the colours on the two supports. On the white paper the colours appear to be lighter and more intense than on the dark paper.

The different tones of green that I have shown in these exercises are the tip of the iceberg. A vast number of greens can be mixed choosing from Daler-Rowney's large colour range. Why not experiment for yourself? Paint a series of simple shapes, using different greens on a variety of coloured papers and note your colours for future reference.

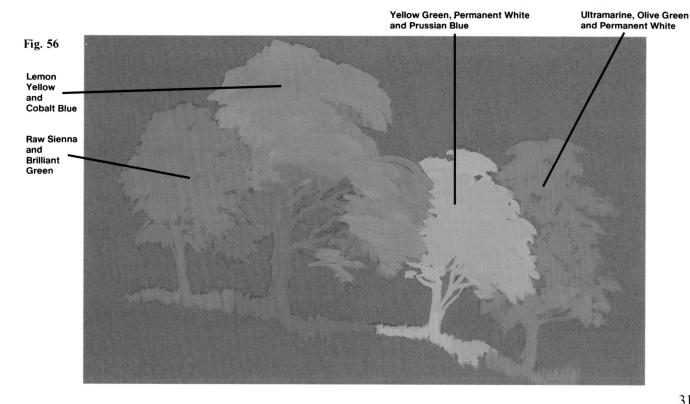

Fig. 56

Lemon
Yellow
and
Cobalt Blue

Raw Sienna
and
Brilliant
Green

Yellow Green, Permanent White
and Prussian Blue

Ultramarine, Olive Green
and Permanent White

TREES

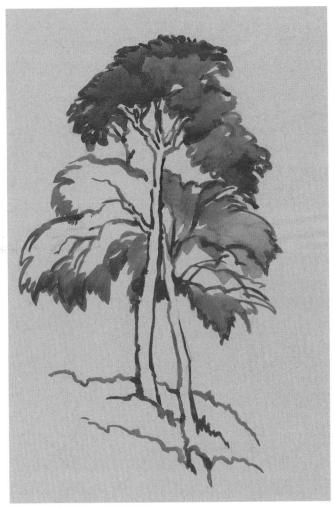

Fig. 57 First stage

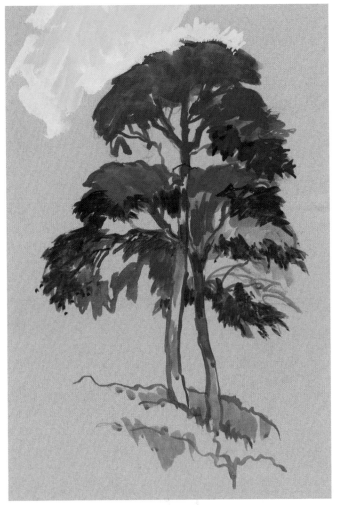

Fig. 58 Second stage

Trees may seem to be complicated subjects to paint, but if you observe them through half-closed eyes you will be able to simplify them to a general silhouette shape. Colour can also be simplified by concentrating on defined areas. For instance, it is helpful to look for the colour variations within the foliage, which can be interpreted by using just a few basic colours from your palette.

First of all, decide on the principal local colour of the tree. Does it strike you at once as being a warm green, or a blue-green such as you might find in an evergreen? Then look at the colour of the leaves through which the light passes – it will probably be a bright yellowy-green, whereas the colour of the foliage in shade will be a cooler, darker version of the local colour. Sometimes a fourth colour can be observed on the leaves that reflect the colour of the sky. The time of day and the weather also play their part in the choice of local colour and, in turn, affect the whole atmosphere of a painting.

The tree painting proceeded in three definite stages.

First stage (fig. 57) I drew the outline of the trees on Blue-Grey Ingres paper with a No. 5 sable brush and dilute Ultramarine. I painted quite freely to capture the general character of the tree shape and did not worry unduly about mistakes, knowing that corrections could be made later when using thicker, opaque colour. Then I massed in the foliage with washes of Ultramarine to give a cool underpainting.

Second stage (fig. 58) I painted the darkest parts of the trees and the shadows on the trunks with thicker paint, using mixtures of Viridian Green and Burnt Umber, and Viridian Green and Raw Sienna. Earth colours added to Viridian Green give a good range of greens for

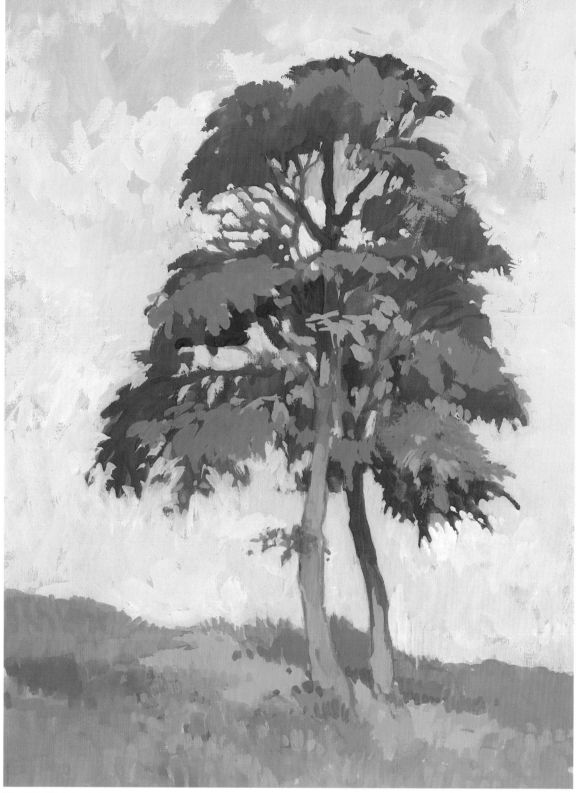

Fig. 59 Finished stage

painting trees. I then diluted the mixtures and used them to paint in areas on the trunks and the ground.

I started to paint the sky with variations of Permanent White mixed with Ultramarine, and Permanent White with Ultramarine and a little Viridian Green to give an azure colour.

Finished stage (fig. 59) With the exception of Permanent White and Burnt Umber, I used the same tree col-

ours to complete the sky, adding creamy hints made by mixing Permanent White with a touch of Raw Sienna.

Next I overpainted parts of the previous tree colours with Viridian Green mixed with Raw Sienna to represent the local colour of the foliage. With small brush strokes I indicated patches of light falling on to the foliage with Brilliant Yellow mixed with Permanent White and a little Viridian Green. I finished by painting these same tree colours in the foreground and on the trunks.

WATER

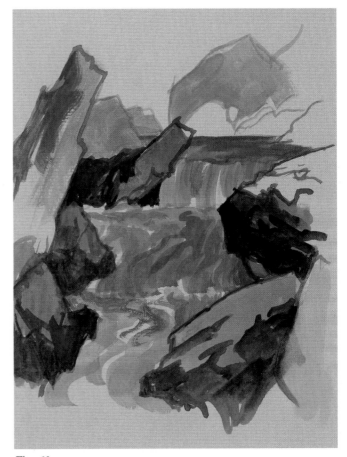

Gouache is an excellent medium for outdoor work, and I often use it for my colour sketches.

Llanberis, North Wales I love the sound of a mountain stream and enjoyed making this on-the-spot study of rocks and water. **Fig. 60** shows how I began. I drew the rocks with a brush and dilute Burnt Umber on Warm Grey Ingres paper and painted the darkest parts with Burnt Umber and Lamp Black. Then, with a larger brush, I registered the water with washes of Olive Green and Burnt Umber, allowing the brush to follow the swirling downward movement of the stream.

In **fig. 61** I superimposed frothing white passages of water on to the darker paint with slightly diluted Permanent White, which allowed some of the Olive Green and Burnt Umber to show through. Then I painted thicker Permanent White gouache on top, spattering it in places to give added sparkle to the water. Finally, I indicated the subtle blue of the sky with a mixture of Permanent White and a little Prussian Blue and Burnt Umber, then painted the grey rocks with fairly dilute Neutral Grey 1.

Fig. 60

Fig. 61

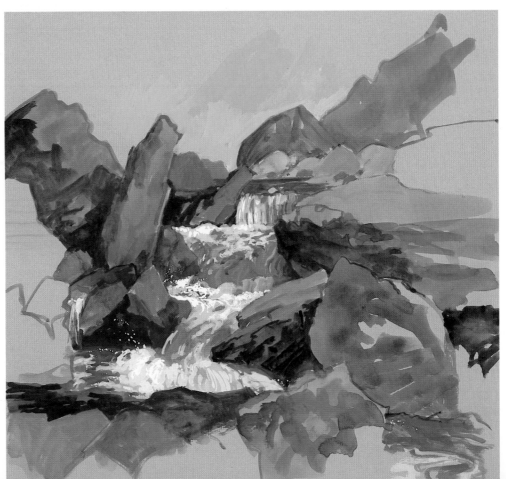

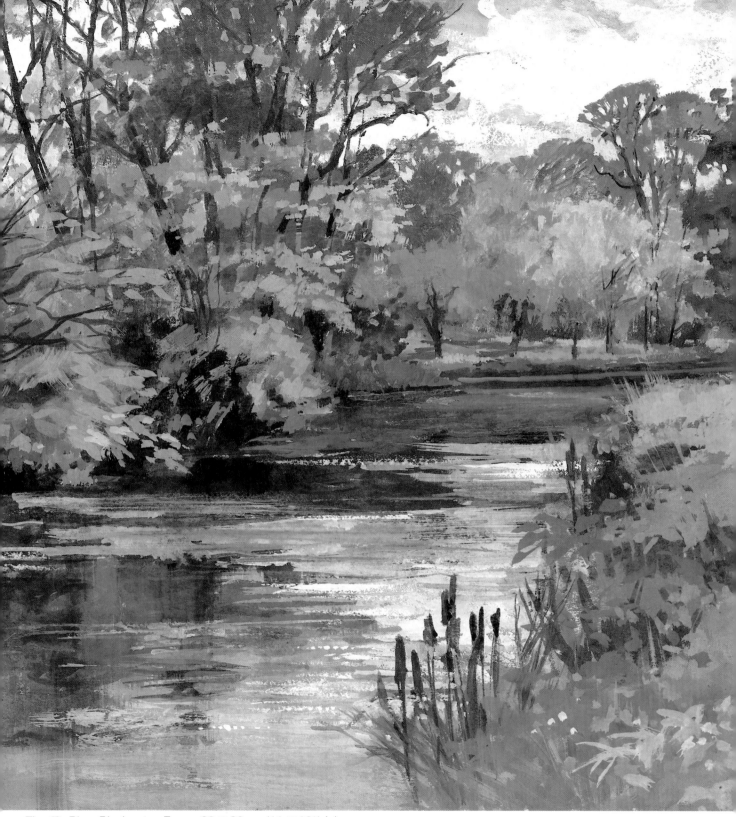

Fig. 62 *River Blackwater, Essex*, 28 × 26 cm (11 × 10½ in)

River Blackwater, Essex (fig. 62) This was painted many years ago and was, in fact, the first gouache painting that I ever made out of doors. I remember that the weather that day was fresh and clear and the water was calm with passages of light from the sky reflected on the surface.

As shown in the Llanberis painting opposite, not only is it easier to paint the dark colour and tone in the water first and then superimpose the surface light, but it is also more effective in giving an impression of depth.

Gouache is an ideal medium for this method of painting water. I used broad, downward brush strokes of dilute dark green in the water beneath the trees, suggesting a hint of reflected colour, and horizontal brush strokes for the areas of reflected light from the sky, indicating the flat surface of the water.

35

BOATS IN HARBOUR

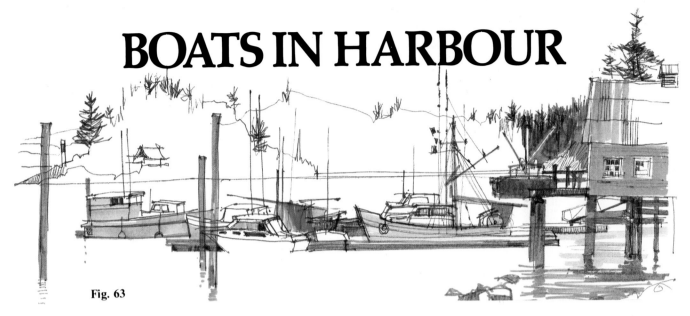

Fig. 63

Most of this painting of Quadra Island in British Columbia, Canada, was made on the spot during a hot, sunny morning. The light was very bright and so I chose to work on a grey pastel paper to cut down the glare from the sun. My time was limited and, as always in these circumstances, I was able to work more rapidly by mapping in the subject with a loose watercolour base, then superimposing gouache on selected areas until I had gained enough information to complete the painting in the studio. I had also made a preliminary sketch on the day before, which provided me with additional detail information.

The sketch (**fig. 63**) was made with a fine, black, fibre-tip pen and colour notes added with broad felt-tip pens. Colour notes on sketches provide useful reminders of colours that you feel are important to keep in the final painting.

First stage (fig. 64) I drew the subject with a No. 7 sable brush, keeping it very simple and using a mixture of Prussian Blue and Burnt Umber watercolour. First of all I established the horizon with a sweep of soft blue colour, then painted the mass of background trees quite crudely with Prussian Blue and Burnt Umber. At this stage I wanted simply to indicate broad shapes, knowing that refinements could follow when I overpainted with gouache. Thin underpainting sinks into the paper and dries quickly, especially on a hot day, and it will not lift off or be disturbed by subsequent overpainting with gouache.

To paint the water, I mixed plenty of Prussian Blue with a little Payne's Grey in a china saucer, then brushed it on with a large, soft wash brush. Although I worked quickly, the wash dried with such rapidity in the hot sun that it looked patchy. However, this did not matter since it was only an underpainting to give tone and depth to the water, and I knew that, at a later stage, I would be superimposing highlights with lighter opaque

paint. It does not matter either if the first loose washes on the water overlap the brush-drawn outlines of the boats. As you can see, the boats are very simple outlines with no details at all, apart from a few lightly suggested masts.

Still using only three colours, I painted the dark trees with a combination of Prussian Blue and Burnt Umber, and the light trees with a dilute mixture of Payne's Grey and Burnt Umber, adding a little Prussian Blue here and there. I then indicated the buildings with the same restricted palette. You will find when working with watercolour washes that they dry with less intensity than expected when applied to a toned paper.

Second stage (fig. 65) I now introduced gouache paint and started with the sky. It was colourful but light in tone so, taking Permanent White, I gradually added Cobalt Blue to it a speck at a time until I attained the desired colour. I mixed my colour in this way because a small amount of dark pigment alters white very rapidly. I used a large, stiff No. 10 bristle brush to paint the sky and covered the paper quite quickly. It was a calm day and the sky seemed rather flat but I could detect layers of slightly varying intensity in the blue, ending with fairly light streaks towards the horizon. As my brush approached the tree line I painted close up to the silhouette shapes of the conifers, sometimes brushing into them. I also had a small sable brush ready charged with the same colour and used this to paint the shapes between the branches, working rapidly before the large brush marks had dried. There was no need to worry about going over edges because I knew that the trees could be adjusted with gouache at a later stage.

The water reflected the mood of the sky with flat streaks of light across the surface. I used the large bristle brush again for this, achieving a broken surface in places as the paint became dry on the brush. This dry-

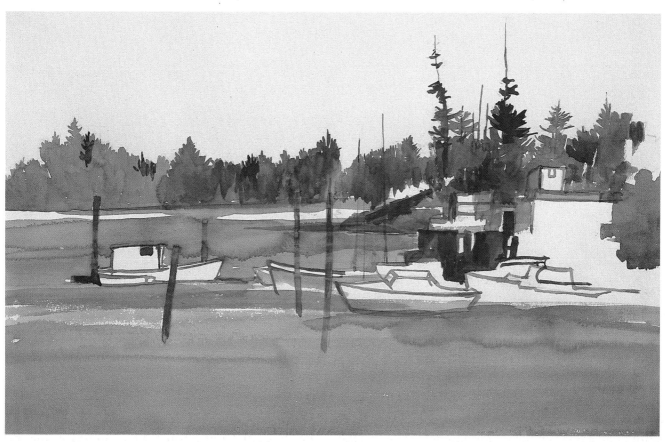

Fig. 64 First stage, above, and **fig. 65** Second stage, below

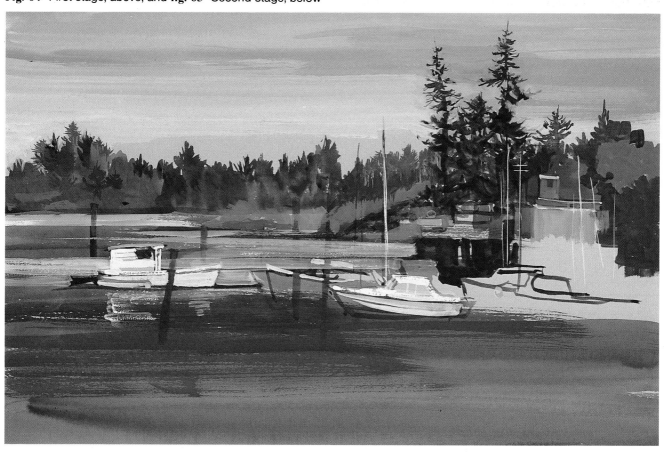

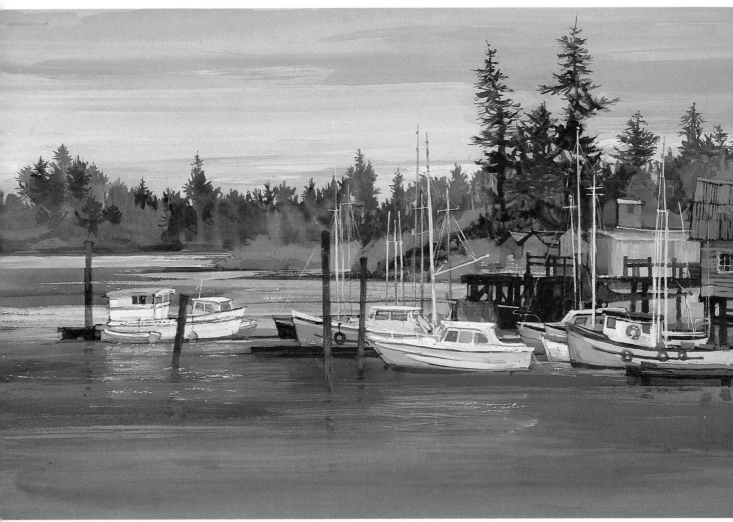

Fig. 66 Finished stage, *Quadra Island, British Columbia*, 33 × 48 cm (13 × 19 in)

brush technique can help to give an impression of sparkle on the water. Touches of Raw Sienna, Burnt Sienna and Permanent White were loosely indicated on the boats, and the nearer shoreline was painted with a mixture of Brilliant Green, Permanent White and Olive Green.

The painting was now at a stage where I could complete it in the studio with the help of the sketch.

Finished stage (fig. 66) To complete the painting I started by working on the line of background trees with gouache and a fine sable brush, painting some of the tree tops over the dry sky paint. The greens were slight variations of the original watercolour underpainting. For the darkest conifers I matched the colour with a mixture of Cobalt Blue, Burnt Umber and Neutral Grey 1 gouache and for the rest of the trees I used mixtures of Olive Green, Burnt Umber and Neutral Grey 1, and Olive Green, Cobalt Blue and Permanent White to give close-toned variations of the original colour.

I then worked on the buildings, using similar colours

together with Cool Grey 1 and Neutral Grey 1. I emphasized the nearest building with a more intense green mixture made with Viridian Green, Permanent White and a little Olive Green.

So far, blues and greens had dominated the painting, so it was a good contrast to use some warm colours for the sails and details. A bright red would have been too strong among all the cool colours, so I used a Copper Brown adjusted with a touch of Neutral Grey 1, and Tangerine with Permanent White and Copper Brown. The creamy colour was a mixture of Brilliant Yellow and Permanent White with a touch of Raw Sienna.

For the masts and rigging I used Permanent White and worked with a fine No. 0 sable brush and a dip pen, darkening the tone of any mast that projected into the sky with some Neutral Grey 1. The hulls of the boats were painted with thick gouache, mainly Permanent White and various shades of blue. Finally, I added details on the windows and roof of the building in the foreground with the same fine sable brush and Cool Grey 1 and Neutral Grey 1.

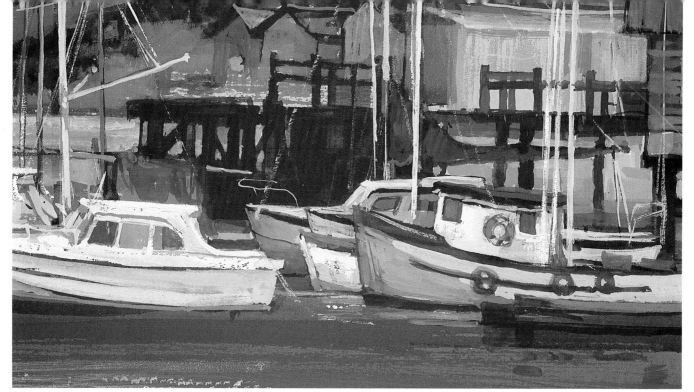

Fig. 67 Detail of **fig. 66**

The details of Quadra Island, reproduced the same size as the original painting, make interesting small paintings in themselves. **Fig. 67** contains a pleasing arrangement of light and dark shapes. The boats are the main interest as they are the lightest features, with light masts superimposed over a darker-toned background. Some of the fine lines were made with a dip pen filled with slightly diluted Permanent White and others were painted with a No. 0 sable brush. The background colours and tones are slightly subdued and so do not detract from the boats. Areas of green and the

patches of warm colour on the sails are a pleasing contrast in a predominantly blue painting.

Fig. 68 makes an interesting composition, with the posts forming a framework to look through towards the distant light on the water. In this detail you can see clearly the build-up of thick paint over thin underpaint, especially on the water. Streaks of light blue have been painted with horizontal brush strokes, sometimes with a broken effect as the paint has run dry, and touches of Permanent White have been added with a fine brush to give a sparkle to the surface.

Fig. 68 Detail of **fig. 66**

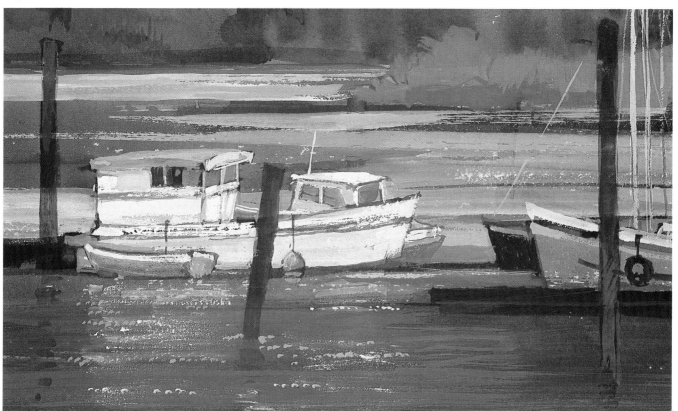

SUMMER FLOWERS

Flowers can display powerfully brilliant colours and at the same time they are delicate, fragile subjects. This combination is elusive when trying to translate it into terms of paint. I find gouache particularly effective for flowers, as the pigment has the desired brilliance, and the consistency of the paint can be diluted with water to enable the colour to be laid as a soft film and capture the translucency of the subject. Flower petals are usu-

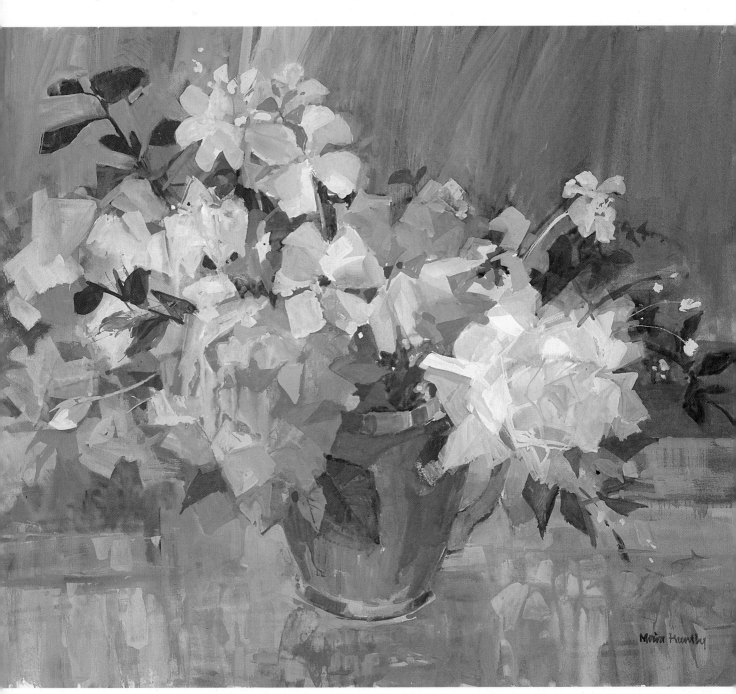

Fig. 69 *Summer Flowers*, 48 × 65 cm (19 × 26 in)

ally soft and smooth, and gouache paint can create this velvety quality. Used at full strength, gouache can also give solidity where needed, for instance on the leaves, stems or vase.

My painting of summer flowers (**fig. 69**) was made on white watercolour paper and I stretched the paper first (see page 22). The flower heads were lightly brushed into position with a large sable brush and dilute Process Magenta and another large brush filled with Spectrum Yellow. I like to have the paint ready mixed in china palettes and two brushes to hand, so that I can work quickly, to help give verve and spontaneity to the painting.

The reflections on the table were underpainted with dilute Process Magenta, and the stems and vase indicated with a smaller sable brush and Process Magenta and a dark green made with a mixture of Viridian Green and Burnt Umber. The background was basically dark green in tone and I varied the colour by laying dilute transparent washes of Olive Green, Viridian Green and Burnt Umber. The vase was painted with Olive Green mixed with a touch of Burnt Umber and Process Magenta mixed with Burnt Umber. The dark washes were kept thinly painted as a foil to the thicker impasto in the principal light flower heads, so emphasizing their brilliance and sparkle.

Some of the smaller flowers have been painted with very dilute Permanent White mixed with a little Process Magenta so that the background shows through and gives a transparent quality to the petals. The shadows in the flower heads have been painted with pure Process Magenta and Spectrum Yellow mixed with a little Viridian Green, to retain the freshness. My aim was to refrain from painting in too much detail so that I could portray more of an impression of flowers.

The background and table top are painted with variations, often muted, of the flower colours, which helps to create a harmony within the painting. The reflections have been kept subtle by using gouache with a wet-in-wet technique and allowing some of the Process Magenta to permeate through to the surface.

The details reproduced on the right emphasize the versatility of gouache and show how it has been used in the painting to portray the brilliant reflective quality of flowers, in contrast to the subtle, discreet tones of the background.

Fig. 70 concentrates on the brilliance of colour obtained by painting with thick gouache over a translucent wash of dilute paint. **Fig. 71** highlights the treatment of the soft reflections on the table, which were achieved with a variety of horizontal and vertical brush strokes painted on to a wet wash. Notice that the reflections are a darker, more subtle version of the same colours as the flowers. When painting reflections, bear in mind that they are never quite as light or dark as the objects being reflected.

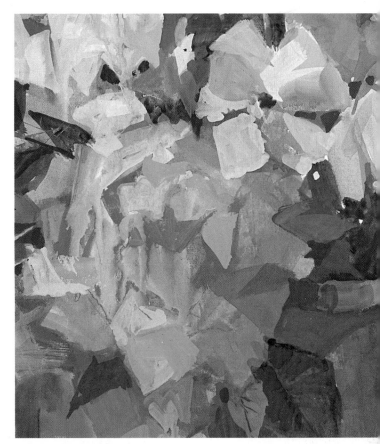

Fig. 70 Detail of **fig. 69**

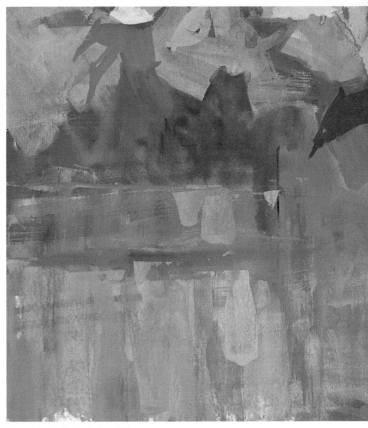

Fig. 71 Detail of **fig. 69**

41

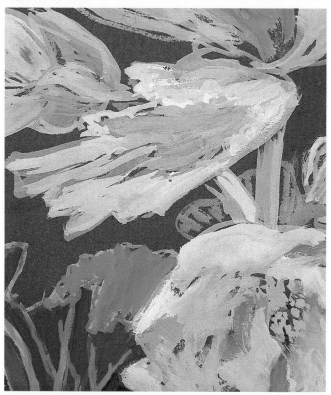

Fig. 72

Fig. 73 Detail of **fig. 74**

YELLOW BEGONIA

The dark support used for the blossom on page 27 proved to be a very effective background for painting light flowers. Here again, I am using a dark paper.

Fig. 72 shows how I started by drawing freely with a brush and a creamy mixture of Permanent White and Lemon Yellow gouache on a dark brown pastel paper. The main attraction of using gouache is that different effects can be obtained by varying the amount of water used to mix the paint. Where the paint is mixed with little, if any, water, the dark background colour is completely covered, creating an impression of strong light reflecting from the petals. When dilute gouache is used, thin veils of colour can be applied to paint the petals, allowing the dark background to show through and suggest soft, shadowy tones.

Variations of shadow colour can be achieved by adding a hint of a related colour, such as Olive Green, to the yellow mixture. The technique of introducing a related colour rather than a darker colour, such as black, to deepen the tone keeps the flowers looking fresh and clean. Shading on the flowers has also been suggested by leaving some thin strips of brown paper unpainted, and this technique has again been used to create the thin-veined texture of some of the petals.

The detail (**fig. 73**) shows the varying consistencies of gouache paint used on the flowers. I used dilute Lemon Yellow and a thin mixture of Lemon Yellow and Olive Green for the shaded areas and left some paper unpainted for the very darkest parts. I built up thicker paint on the lightest areas, using Lemon Yellow and a mixture of Permanent White and Lemon Yellow.

I painted the leaves in three stages (**fig. 74**). First, I washed dilute Red Earth over them to give an underlying warmth and a red edge, which are characteristics of the begonia leaf. The original drawing of the veins could still be seen through the dilute paint.

For the next stage, I mixed a fairly thick light green with Olive Green and Permanent White, and used it to paint over the veins and in the light areas on the upper side of the leaves.

For the third stage, I painted between the broad veins with dilute Olive Green and a mixture of Ultramarine and Olive Green. This had the effect of softening the Red Earth wash while still allowing it to glow through. I left untouched the red wash at the edge of each leaf. Finally, I painted the flowerpot with dilute Red Earth, leaving part of the paper to show through.

Fig. 74 *Yellow Begonia*, opposite, 50 × 36 cm (20 × 14½ in)

42

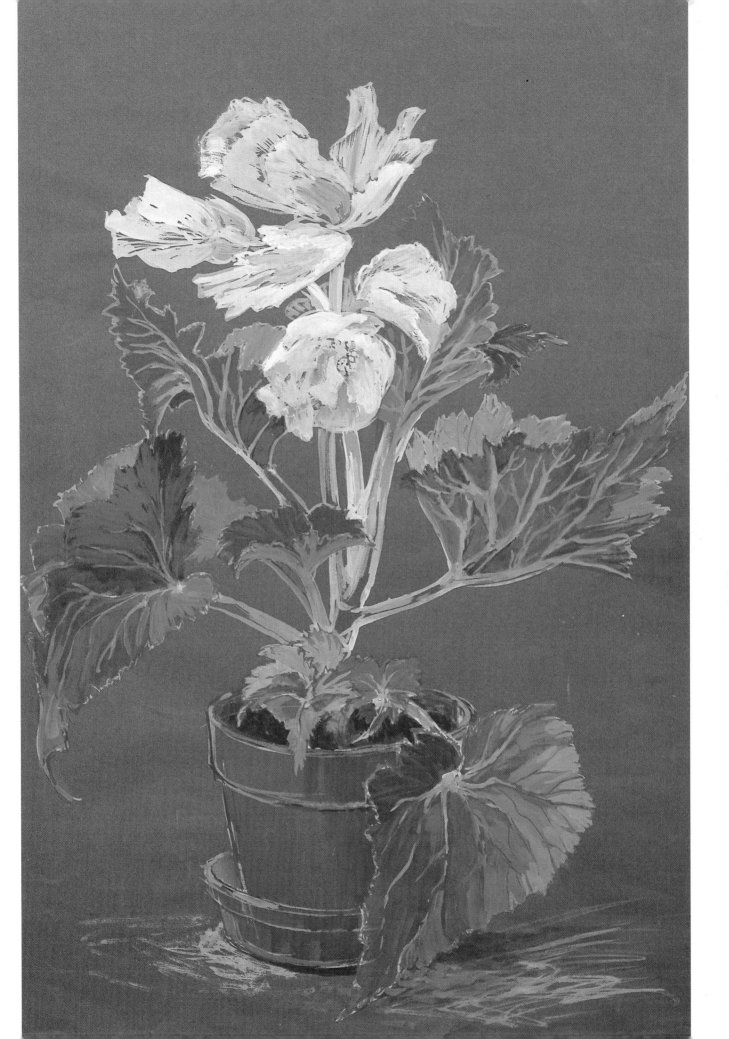

STILL LIFE

I painted this still life on a grey pastel paper and applied gouache over strong watercolour washes, which provide a darkened ground that emphasizes and makes full use of the opaque quality of gouache paint. This technique produces powerful tonal contrasts, for instance around the cut surfaces of the apples which appear sharp against the dark ground, and, by building up the gouache paint over the underpainting, light tones and an impression of solidity can be achieved.

For a more interesting viewpoint I placed the pots and apples on a low table, so that I could look down on them and see more clearly the curve of ellipses and spaces between them. These spaces are visually interesting shapes in themselves and form a part of the painting that is of equal importance to the still life objects.

The pots were subtle in colour and I detected a certain overall warmth, and the apples, though fresh green in colour, also seemed to possess a warmth in part. I decided that I would start with washes of Cadmium Orange watercolour, with the intention of allowing some of the colour to show through subsequent paint and so permeate the painting with warmth, and introduce washes of Hooker's Green watercolour on the areas of cooler shadow.

I mixed plenty of each colour in two separate saucers and had two large wash brushes ready to hand. Then I took a hard look at the still life group and tried to see in my mind's eye where I would place each object on the paper.

First stage (fig. 75) I did not do any preliminary drawing but picked up a large brushful of Cadmium Orange watercolour and applied the first free washes, loosely indicating the positions of the objects. Washes of Hooker's Green were immediately applied with the second brush, sometimes overlapping the orange washes. When using transparent watercolour for initial

Fig. 75
First stage

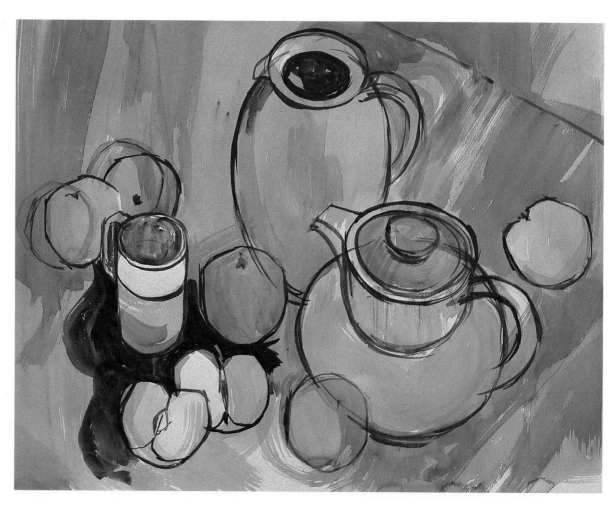

44

washes, you will find that you can make the mixture quite bright because as it dries the grey colour of the support shows through and gives a soft effect.

Having laid in the subject generally, I changed to a smaller sable brush (No. 6 or 7) and firmed up on the drawing of the objects using a dark mixture of Indigo and Burnt Umber watercolour. During this process I made a few alterations in the positioning of some of the apples and the tall pot. There is no need to worry if your brush line is made too thick or is wrongly placed because it can be easily adjusted at a later stage with the covering power of gouache.

As you can see on the pots, I drew the rounded shapes in an almost continuous line. To do this I stood back from the easel and let the whole arm swing from the shoulder to draw the curved outlines. Whatever tool you are using for drawing, the resulting freedom of line aids in the achievement of a more accurate drawing, particularly of rounded objects. In this painting the unwanted parts of the drawn line would be covered by opaque gouache paint.

Second stage (fig. 76) I used washes of Indigo and Burnt Umber with a larger brush to map in the areas of dark tone and, in doing so, I was also able to redefine

the shapes of some of the objects as I worked. At this stage the painting was quite dark but colourful and I felt really excited about starting to paint the pale tones with gouache, which is such an effective medium for establishing the light in a painting.

Using a clean palette, I squeezed out some gouache paint, choosing Raw Umber, Burnt Umber, Burnt Sienna, Brilliant Green, Olive Green, Lemon Yellow and plenty of Permanent White. A variety of subtle colours can be achieved by intermixing with this limited palette. The green apples were painted with mixtures of Brilliant Green, Olive Green, Lemon Yellow and Permanent White in varying proportions, and for the russet-coloured apples I introduced Burnt Sienna. For the pots I used Permanent White with a little Raw Umber or Burnt Umber, and Permanent White with Raw Umber and Olive Green to make lovely, subtle colours. For the darker tones on the pots I used Burnt Umber and Olive Green mixed with a small amount of Permanent White, and Burnt Sienna with Brilliant Green and Lemon Yellow.

Finished stage (fig. 77) I began to develop the background, keeping it low in tone and building it up with gouache applied in dabs and short, random strokes. I

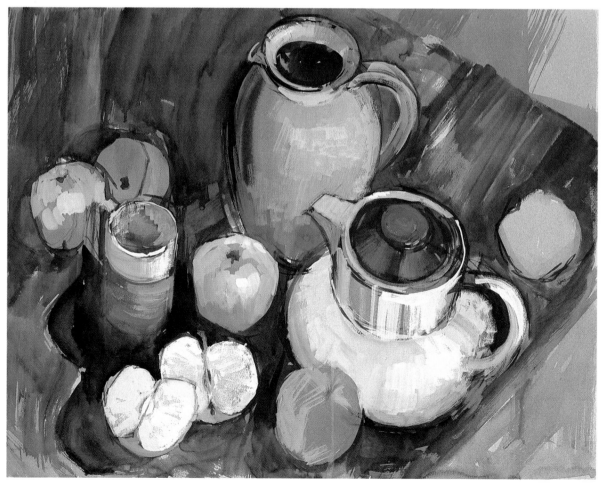

Fig. 76
Second stage

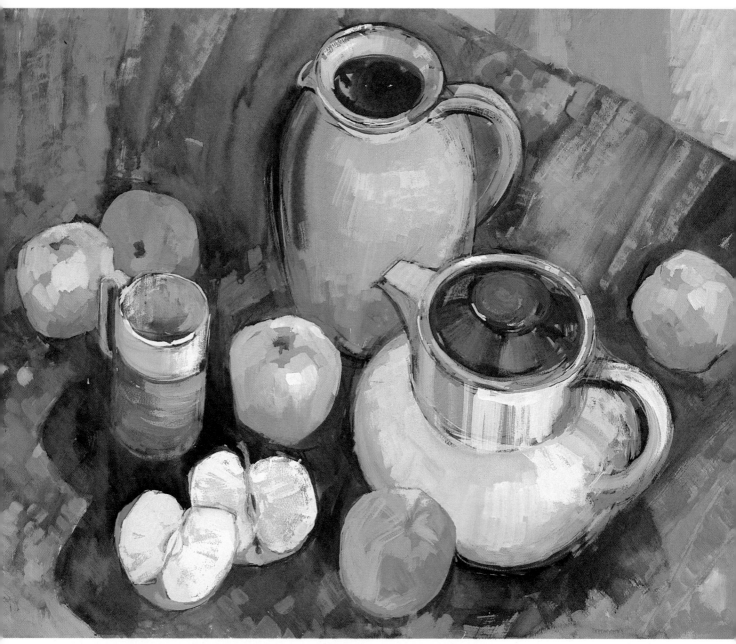

Fig. 77 Finished stage, *Still Life with Pots and Cut Apples*, 48 × 63 cm (19 × 25 in)

used a stiff bristle brush and the same colours as for the apples and parts of the pots but muted so that the background does not compete with the principal objects. These muted colours were obtained by mixing small amounts of Burnt Umber and occasionally a little Neutral Grey 1 into the greens, and by using only a little Permanent White in the colour mixes.

Finally, I completed the apples and the pots with short, positive brush strokes of fairly thick gouache colour. I made no attempt to soften these brush strokes – they are direct statements made to follow the general contours of the rounded surfaces and give a vitality to the painting.

The texture of the brushwork is seen most clearly in the details, and especially in the apples in **fig. 78**. Here, thick almost dry paint has been dragged over the underpainting, creating an intense highlight that suggests the moist, glistening, cut surface of the apple.

Fig. 79 is a detail of the area near the edge of the painting, showing a part of the background that needed to be almost out of focus. Here I used soft, muted colours and a little gentle texture, to create a contrast to the more intense areas of light in the painting.

Fig. 80 shows the top of the teapot, which again is subdued compared with the apples and has only one flicker of highlight on the rim. Throughout the painting I tried to contain the lights within one part of the painting and not scatter them indiscriminately.

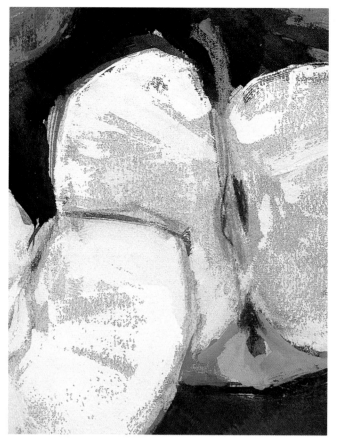

Fig. 78 Detail of **fig. 77**

Fig. 79 Detail of **fig. 77**

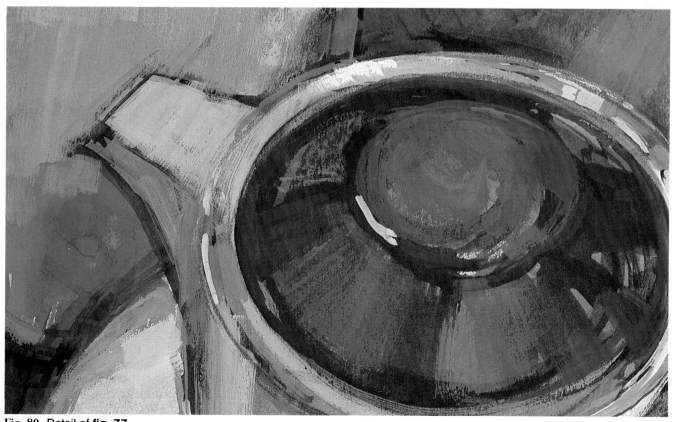

Fig. 80 Detail of **fig. 77**

PORTRAITS

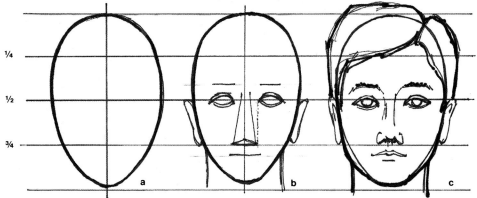

Fig. 81 Front view

Simple proportions

This is a very brief introduction to drawing heads. The proportions used in the exercises are based on average measurements; in reality we all differ from the average, which is why we are recognized.

Fig. 81 shows how I started by drawing horizontal lines spaced equidistantly. The centre line halfway down represents the eye level; the line a quarter way down is the hairline and the three-quarter line is the nose level.

All heads are basically egg-shaped with the widest part uppermost, so in **fig. 81a** I drew a vertical line, which I used to dissect an oval shape.

Fig. 81b shows the nose simplified as a pyramid; the ears situated between the eye and nose levels; the mouth line closer to the nose than to the chin and the line of the brow nearer to the eyes than the hairline. Notice that the width between the eyes allows space for a third eye. The dotted line relates the width of the nostrils to the inner corner of the eye.

In **fig. 81c** you can still see the egg shape but the profile has been slightly widened with the addition of the jaw line and enlarged with the bulk of the hair.

The three-quarter view of a head (**fig. 82**) is more difficult to draw and involves some perspective. It helps if you can imagine that the head is like an egg with a ribbon tied round the halfway line. **Fig. 82a** shows how the quarter and three-quarter lines are also curved and the vertical line is angled so that the egg shape is slightly tilted. Notice the placing of the ear between the curved lines of the nose and eye levels.

In a three-quarter view we see more of one side of the face than the other. **Fig. 82b** shows how the nose projects and hides part of the cheek, and the chin juts out slightly. The dotted line between the nostril and inner corner of the eye now follows the tilt of the egg.

In the side view (**fig. 83**) the egg is tilted further, but the main features remain between the same levels as before. The profile of the egg shape is now considerably altered to show the planes of the face, and there is a definite angle to the neck.

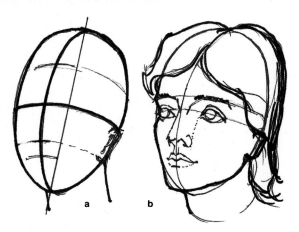

Fig. 82 Three-quarter view

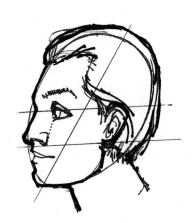

Fig. 83 Side view

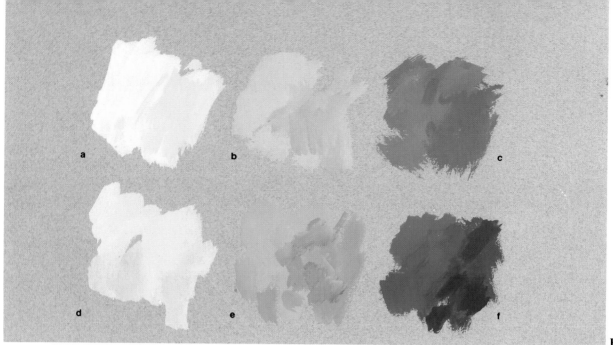

Fig. 84

Mixing flesh colours

Most of the colours I have used for painting flesh are earth colours, which have a natural warmth in keeping with skin colour. The range of tones shown can easily be extended by varying the proportions of each colour in the mixing. When mixing light tones remember to start with the lightest pigment and gradually add stronger, darker pigment to it until you achieve the tone you require.

In **fig. 84a** I started with Permanent White and added a little Raw Sienna to give a very pale, creamy colour, which is good for skin over bone. **Fig. 84b** is Permanent White with Raw Sienna and a little Red Earth to give a warmer flesh tint. For **fig. 84c** I mixed Raw Umber with Red Earth and added a little Permanent White.

Figs. 84d–f show a slightly cooler range of flesh tints. **Fig. 84d** is Permanent White with a little Red Earth, and for **fig. 84e** I used the same mix but added a little Burnt Umber. For the dark flesh colour in **fig. 84f** I used Ultramarine and Burnt Sienna with Permanent White.

You could also experiment by using other earth colours or by substituting Crimson for Red Earth.

Mixing hair colours

Here again I have used several earth colours, which help to harmonize the hair and the skin, as follows:
Blond hair (fig. 85a): mixtures of Permanent White, Raw Umber, a little Lemon Yellow and a hint of Ultramarine in the shadows.
Red hair (fig. 85b): Burnt Sienna, Red Earth and Burnt Umber.
Brown hair (fig. 85c): Burnt Umber and Ultramarine with a touch of Burnt Sienna.
Black hair (fig. 85d): Prussian Blue and Lamp Black, Prussian Blue and Vermilion Red or Burnt Sienna.

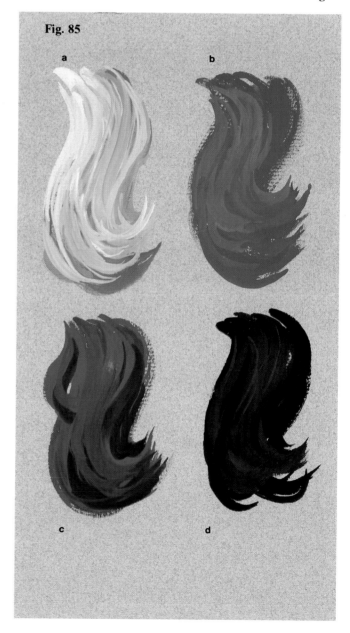

Fig. 85

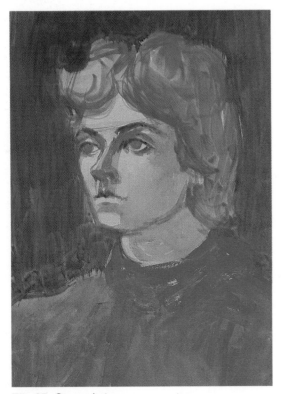

Fig. 86 First stage

Portrait of Aline

Before starting to paint a portrait from real life you need to spend some time looking at the model and measuring with your eye. Try to plan the picture area early on, including the background, which forms an important part of the painting.

First stage (fig. 86) Painting directly on to tan pastel paper, I started by mapping in the position of the head and shoulders with a No. 5 soft brush and a mixture of very dilute Ultramarine and a little Burnt Sienna. I then painted the shadows freely using the same cool mix and sometimes allowing the brown to dominate.

Second stage (fig. 87) My next aim was to cover the support using a large brush and thin underpaint to establish the colour and tone. I used dilute Burnt Umber for the hair, Burnt Umber and Ultramarine on the left of the background and Olive Green mixed with a small amount of Lamp Black on the right, and Ultramarine for the jumper.

Third stage (fig. 88) I painted the face and neck with a moderately dilute mixture of Permanent White, Red Earth and a little Raw Sienna to give a general flesh colour. I worked more fully on the background washes with Olive Green and Burnt Umber adjusted in places with Neutral Grey 1. I then painted the mid-brown hair colour with Raw Umber and Burnt Umber.

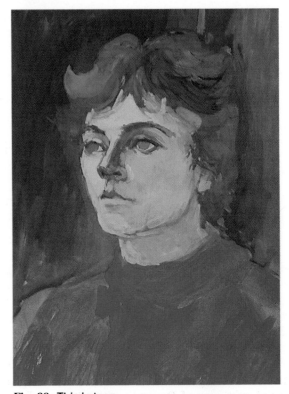

Fig. 87 Second stage

Fig. 88 Third stage

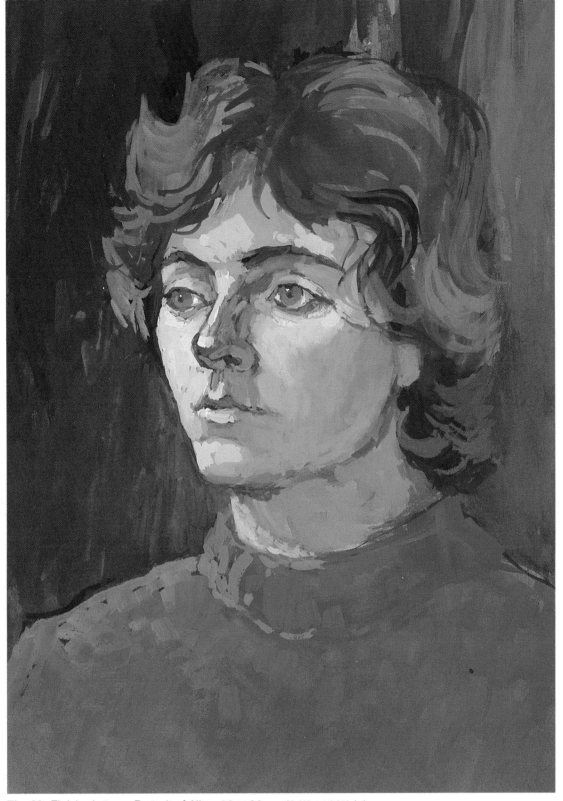

Fig. 89 Finished stage, *Portrait of Aline*, 36 × 26 cm (14½ × 10½ in)

Finished stage (fig. 89) Sometimes when you paint a portrait with several sittings there are minor differences to contend with; for instance, the hair may be brushed differently each time. As you can see from my demonstration, these differences become part of the development of the painting.

In this finished stage light and dark tones, together with details, have been added to the face. For the light tones I used mixtures of Permanent White and Raw Sienna, Permanent White and Red Earth, and Permanent White with a touch of Vermilion Red and Raw Sienna. For the shadows I used mixtures of Red Earth, Burnt Umber, Burnt Sienna and sometimes a little Permanent White, allowing part of the underpainting to show through to give the deepest shadows.

I added highlights in the hair with Raw Sienna and a little Burnt Sienna and finally I completed the blue jumper with Ultramarine adjusted with Cool Grey 1.

BUILDINGS

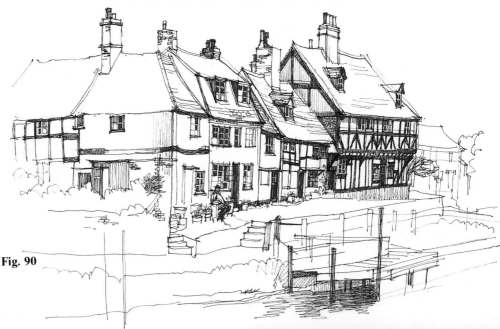

Fig. 90

I particularly like painting buildings because, as a subject material, they provide plenty of opportunity to employ many of the gouache techniques already described. Thick gouache has an affinity with the solidity of buildings and, by varying the consistency of the paint, not only can many textures be achieved but minute details can be added using gouache with a pen or fine brush.

Houses in Tewkesbury The sketch (**fig. 90**) was made on the spot with a fibre-tip pen, which is capable of producing a very fine line, and the effect of a thicker black line can be achieved by drawing a number of fine lines together.

For my illustration of Tewkesbury, which was based on the sketch, I chose a black background to provide an example of the striking effectiveness of a toned paper in utilizing the qualities of gouache. The black background also provides a useful exercise in the technique of painting light tones and leaving the paper to act as the darks.

When painting on a very dark ground it is easier to draw the subject first with a white conté pencil, as shown in **fig. 91**. Painting with white gouache on black paper is particularly suited to the black-and-white Elizabethan period of architecture and a useful technique to employ when sketching this type of building.

For the finished painting (**fig. 92**) I used gouache with varying amounts of water. Where it is painted thickly with hardly any water, the covering power is total, and where the paint is diluted, as on the pavement and steps, it is transparent enough to allow the paper to show through and lower the tone. Gouache has also

Fig. 91

been applied with a dry brush on some of the walls, allowing the black paper to break through and give a good, rough wall texture. Where there are window-panes, beams or dark doorways, the black paper has been left unpainted.

Fig. 93, which is a detail of the finished painting, shows the variety of coverage obtainable when painting on dark paper. The wall in shadow on the left was painted with undiluted gouache dragged over the paper with a dry brush, so that much of the black background shows through. The middle part was painted with a creamy semi-dilute paint, which allows only a hint of black to show beneath, and on the right the gouache has been applied thickly with a bristle brush to give a little texture.

Fig. 94 shows how the paper serves as the black line work of the beams between the white-painted walls, a reversal of the way in which I drew the beams in the sketch.

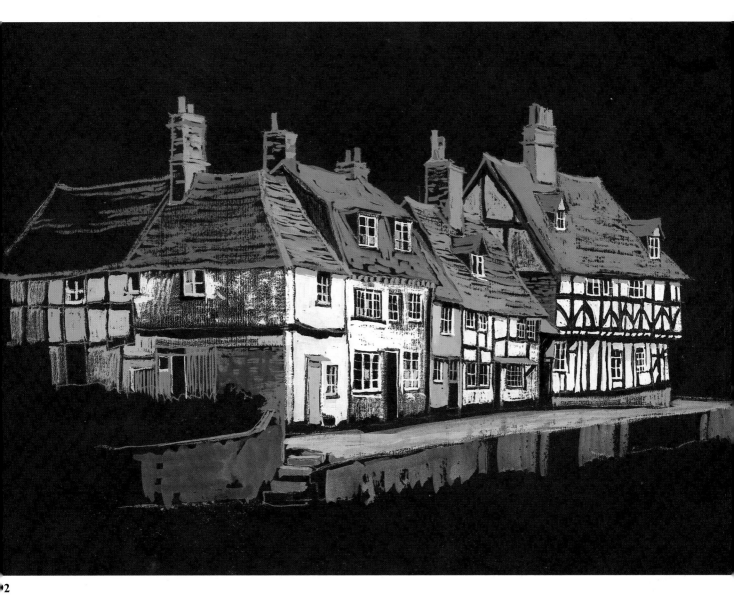

Fig. 94 Detail of **fig. 92**

Fig. 93 Detail of **fig. 92**

The Rose and Crown I came across this interesting jumble of buildings in Colombo Street on London's South Bank and made a sketch (**fig. 95**), which inspired the studio painting opposite. In this painting I employed many of the techniques shown earlier in the book, and the details below isolate some of them.

Figs. 96 and **97** show how the different effects of building surfaces have been achieved by painting gouache over dilute washes. Passages of stiff dry-brushed or spattered paint, dilute milky paint and areas of original wash combine with details drawn with a dip pen or fine brush to give brick textures.

I began the painting (**fig. 98**) by covering a sheet of white HP watercolour paper with a dilute wash of Tangerine mixed with Vermilion Red gouache. This wash can be seen untouched in the sky, the road and the upper parts of the building. With a fine brush and dilute Burnt Umber, I drew the outlines of the buildings, then, with a big, flat brush, washed in patches of colour, using Copper Brown, Vermilion Red and a mauve made with Process Magenta and Lamp Black.

I applied some of the washes wet in wet and some in flat, hard-edged slabs of bright, thick paint. When these were dry, I defined the details with fine brush drawing, then washed in the dark, shaded areas with Raw Umber and a little Olive Green.

I subdued some of the bright areas of paint on the background buildings with very dilute films of pale blue made with Permanent White and a little Cobalt Blue and pale mauve made with Permanent White, Process Magenta and Cobalt Blue. Finally, I dragged the same pale colours, which were only just moistened, over parts of the buildings, to suggest texture.

Fig. 95

Fig. 96

Fig. 97

Fig. 98 *The Rose and Crown, Colombo Street, London*, opposite, 53 × 39 cm (21 × 15½ in)

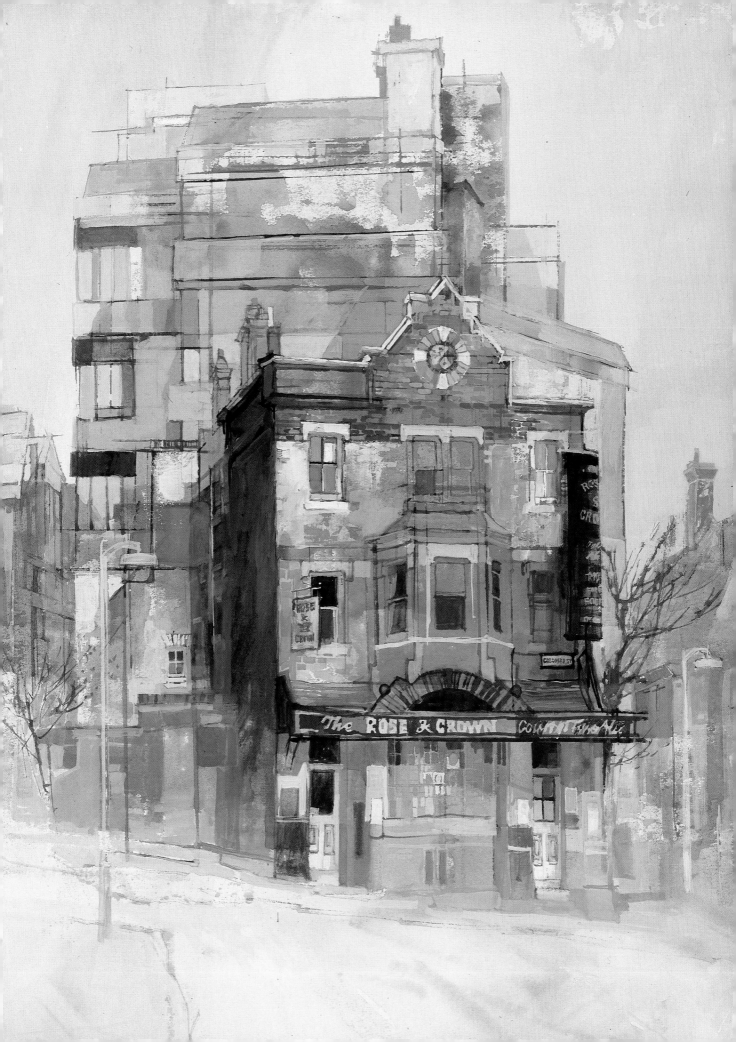

BUILDINGS IN LANDSCAPES

Fig. 99

Cottages in Yorkshire I started this project by making a sketch on the spot (**fig. 99**) to give me information for a studio painting. As I looked at the scene I knew that my main aim would be to create an impression of intense light in the sky.

The brightest light was concentrated behind the darkest buildings (see the detail, **fig. 100**) and illuminated the surrounding fields, and to achieve this effect I employed the technique of painting with light gouache over a darker watercolour background.

I began the painting on watercolour paper by indicating the buildings with a brief pencil line and then washed Prussian Blue watercolour over the sky, roofs, shadows and immediate foreground, and Raw Sienna over the middle distance and some parts of the building (**fig. 101**). Some interesting cloud effects occurred unintentionally when I applied the blue sky wash. I was tempted to retain them but, as you will see in the finished painting, I overpainted them because they did not contribute to the sky effect I had in mind. I painted the hills, added details and strengthened the buildings with a mixture of Burnt Umber and Prussian Blue watercolour.

Fig. 102 shows the overpainting of the sky with very pale pink gouache, which I made with Permanent White and a speck of Vermilion Red and applied thickly above the chimneys and diluted as it spread outwards so that the blue underpainting breaks through. I painted the grassy areas in short, vertical strokes with a 12 mm (½ in) chisel-ended brush and various mixtures of Brilliant Green, Permanent White, Lemon Yellow and Raw Sienna, and I added Cool Grey 1 and Neutral Grey 1 over parts of the roofs. I completed the painting with touches of warm colour on the buildings made with Burnt Sienna and Raw Umber and for the extra-light passages I added a little of these colours to Permanent White.

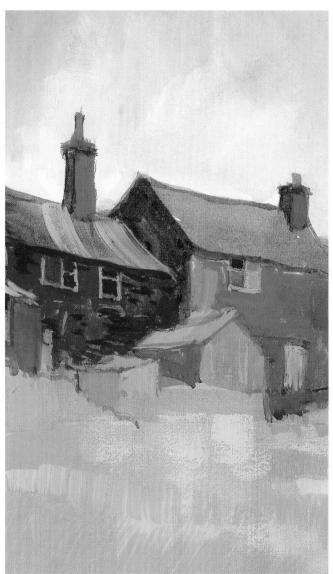

Fig. 100 Detail of **fig. 102**

56

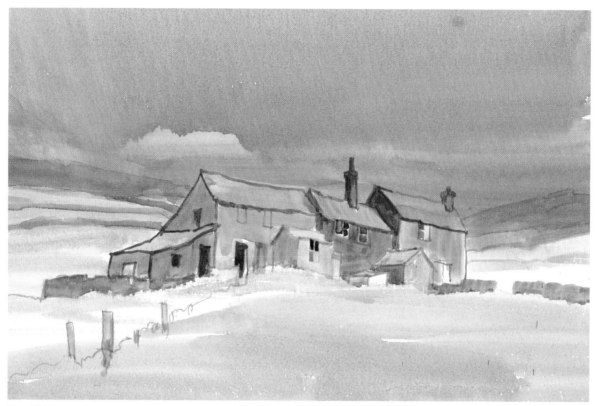

Fig. 101

Fig. 102 *Cottages, Rishworth Moor*, 24 × 35 cm (9½ × 14 in)

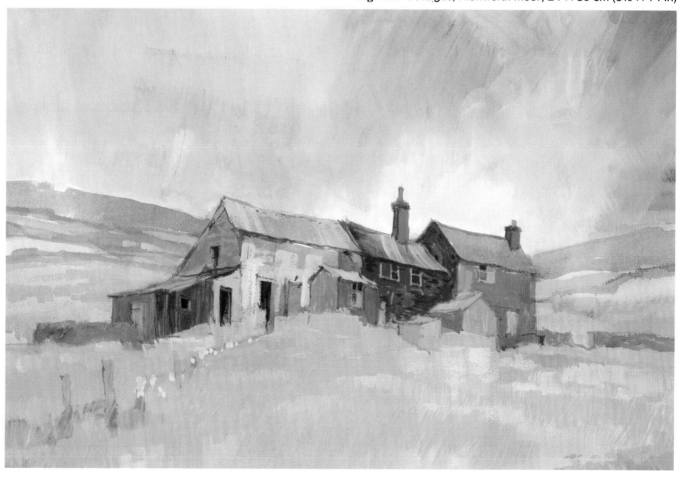

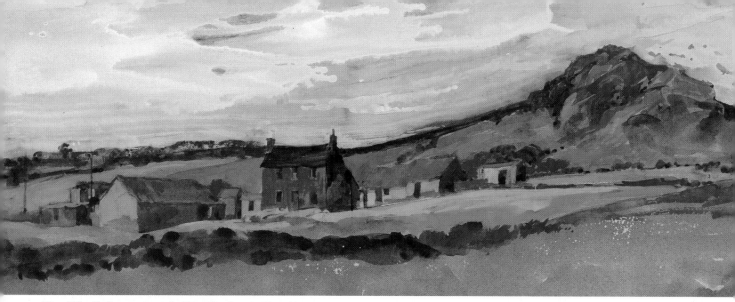

Fig. 103 *Cottages near St David's, South West Wales*, 15 × 40 cm (6 × 16 in)

These three landscapes were all painted out of doors on toned pastel paper or board.

Cottages in Wales On the day I painted the cottages near St David's in Wales (**fig. 103**) the weather was windy and the sky threatened rain, which influenced my choice of grey pastel paper.

I started by painting the sky with a very dark wash of Payne's Grey watercolour, which dried quite rapidly in the wind. I then painted over the top with a large brush and dilute Permanent White gouache. While it was wet I tilted the paper to encourage random runs in the paint, which helped to create a feeling of the movement of clouds scudding across the sky.

I kept the colours of the landscape and buildings muted and fairly low in tone, in keeping with the weather that day.

Pembrokeshire farm I found the subject for this painting (**fig. 104**) quite close to the cottages shown above. The day was a little brighter, but still quite grey with only spasmodic bursts of sunshine lighting up the scene. I used mixtures of Permanent White and Lemon Yellow with Viridian Green or Brilliant Green to catch the fleeting effects of sunshine on the fields. For the buildings I used a creamy beige made with Permanent White to which I added Raw Sienna and a touch of Cool Grey 1 – pure white would have been too stark. I kept the rest of the painting fairly low in tone to emphasize the few patches of light.

Fig. 104 *Farm in Pembrokeshire*, 25 × 43 cm (10 × 17 in)

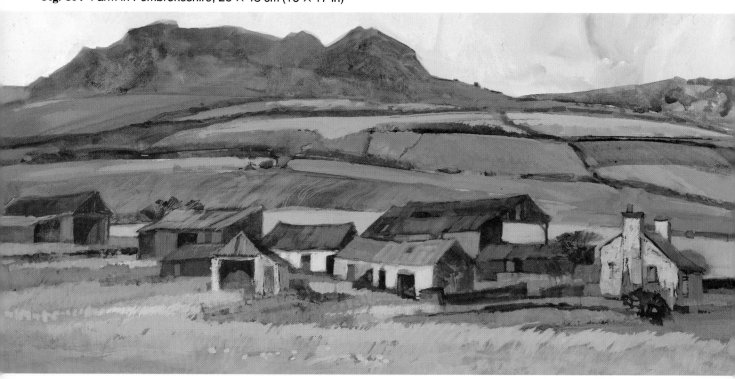

Fig. 105 *Cottages, Caithness, North East Scotland*, 36 × 39 cm (14½ × 15½ in)

Cottages, Caithness, North East Scotland For this painting **(fig. 105)** I used a piece of toned mounting board, a useful support when working out of doors as it is thick enough to enable you to dispense with a drawing board, which is heavy to carry and needs the paper to be firmly clipped on to it to prevent it from flapping in the wind.

The lowering sky depicted is an effect very often encountered when painting the British landscape. I wanted to convey the feeling of lonely buildings dominated by a vast landscape, and so I placed them high in the painting and very small against the big foreground. I kept the foreground relatively simple with just a few long grass details, so that the dark and ominous far distant hills seen against a clearing sky form the main impact of the painting. This effect is assisted by the light grass path zigzagging to the road, which leads the eye into the distance.

LANDSCAPE

This landscape was painted on location in Sutherland, North West Scotland, on a fine, airy day with very little wind. Much of Sutherland is still a wild and exciting place. The landscape is vast, and I felt impelled to work on a large piece of paper. I chose an Imperial-sized (762 × 559 mm/30 × 22 in) heavy watercolour paper, with a rough (Not) surface to suit the subject of textured rocks, mountains, and sparkle on the water.

We have seen that it is a common practice to paint with gouache on a toned paper and add the lighter features. However, where the subject contains large areas of light, as can be seen, for instance, in the sky, distant mountains and water in **fig. 106**, it is more effective to work on a light-coloured paper and allow much of it to be retained in the finished painting.

I started by tinting the brilliant white paper with a very pale wash of French Ultramarine and a touch of Cadmium Red watercolour. When this was dry, I registered the finely detailed shapes of the mountain tops with No. 0 sable brush and Payne's Grey watercolour,

then changed to a No. 2 brush and dilute Burnt Umber gouache to draw the nearer hills and foreground rocks.

I used gouache for all my subsequent work on this painting. I painted the rocks and middle-distance hills with semi-dilute Raw Umber and Red Earth to which I added some acrylising medium. The addition of this medium alters the character of gouache paint by rendering it waterproof, and so, later on, I was able to paint another layer on top without dissolving the first one.

Before the paint on the hills in the middle distance was dry, I scraped a few light lines through the paint with a palette knife, as shown in the detail (**fig. 107**). Gradually, the darker tones were built up with thicker Burnt Umber gouache and acrylising medium, but in contrast to this, much of the initial pale watercolour wash on the distant mountains and the water in the immediate foreground was retained, allowing the white paper to reflect the light and give sparkle to the subject.

I darkened the water in places with thin under-washes of Ultramarine and Burnt Umber, then super-

Fig. 106 *Sutherland, North West Scotland*, 48 × 69 cm (19 × 27½ in)

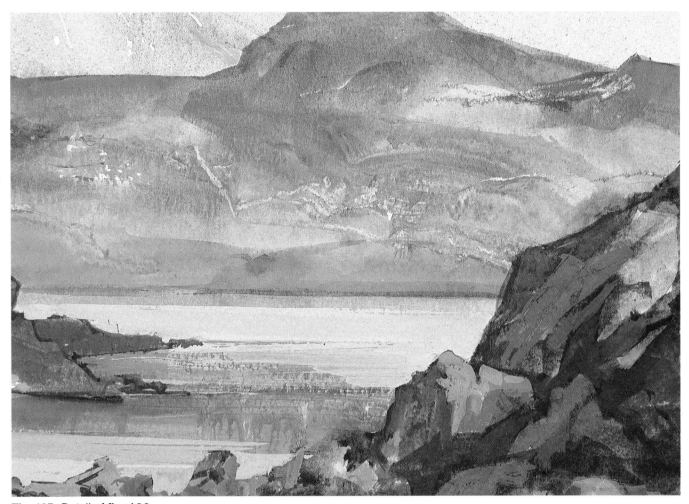

Fig. 107 Detail of **fig. 106**

Fig. 108 Detail of **fig. 106**

imposed some horizontal streaks of Permanent White mixed with a touch of Ultramarine and Cool Grey 1, to show reflected light from the sky. This treatment gives a stillness to the water that evokes a feeling of calm. When mixing pale colours, do not forget to start with the white and only sparingly add darker or stronger pigments to it. The warm colours in the middle distance needed softening to give them recession, and so I washed over them with a very dilute film of the light colour I had used on the water (see **fig. 107**).

I then introduced some subtle colours into the painting with various mixtures: Olive Green, Raw Umber and Permanent White; Olive Green and Cool Grey 1; Brown Pink, and Olive Green mixed with Brown Pink (see the detail, **fig. 108**). These pigments provided me with a range of lovely, subtle landscape colours, ideal for this particular part of the world. I added a few touches of pale blue on the rocks (mainly Ultramarine mixed with Permanent White) to reflect the colour of the sky. Finally, I painted hints of clouds and a few snow-filled crevices on the mountains with a very light cool colour made by tinting Permanent White gouache with a touch of Payne's Grey watercolour.

SKETCHING WITH GOUACHE AND INK

Sketching is often regarded as a kind of 'throw-away' process, done in idle moments and having no particular value, but this is far from the truth. Turner had sketch books specially made with blue-grey paper in which he made exciting sketches with gouache and ink or pencil. Spontaneous sketches can possess a vitality and directness sometimes missing in a more considered finished painting.

Gouache and black indian ink combine well for painting and sketching, and the exercises on this page show different approaches to mixing the two media. The strollers in **fig. 109** were freely sketched with pen and ink and brush and ink, and the light tones, pattern and details were added with Permanent White gouache. The Tan Ingres mounting board used for the sketch demonstrates the effectiveness of combining black ink and white gouache with a strong-toned background. The mountain landscape in **fig. 110** is an outdoor colour sketch worked fully in gouache on a grey pastel paper, and the ink has been added on top, with a dip pen, to record details.

Fig. 109

Fig. 110

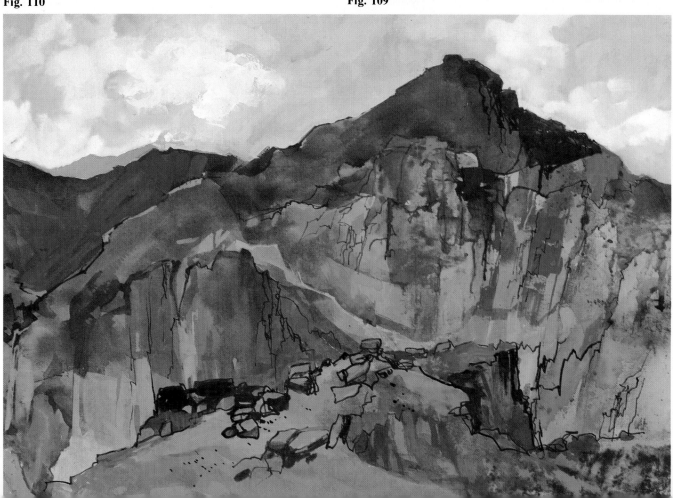

ACRYLISING MEDIUM

Acrylising medium is a resin additive that makes gouache water-resistant. In practice this means that, by adding the medium to gouache, you can overpaint without picking up the first layer. Acrylising medium gives the paint a different consistency and enables thick layers to be built up as impasto and subsequent thin layers to be painted on top as a glaze.

Fig. 111a shows Brilliant Green and acrylising medium mixed in the proportion of approximately one part medium to four parts paint and applied with a brush. It has dried with a velvety surface. **Fig. 111b** is the same mixture applied with a palette knife, to give a

thicker surface texture. In **fig. 111c** the green mixture was brushed on and left to dry, then overpainted with Permanent White gouache without medium. The white has remained clean and has picked up none of the green colour.

Care should be taken to rinse palettes and especially brushes immediately after using acrylising medium, to prevent the paint drying hard.

Fig. 112 shows the first stage of an exercise in painting with gouache and acrylising medium. I started by painting the sky with Rowney Blue mixed with a touch of Lamp Black and some Permanent White. I then

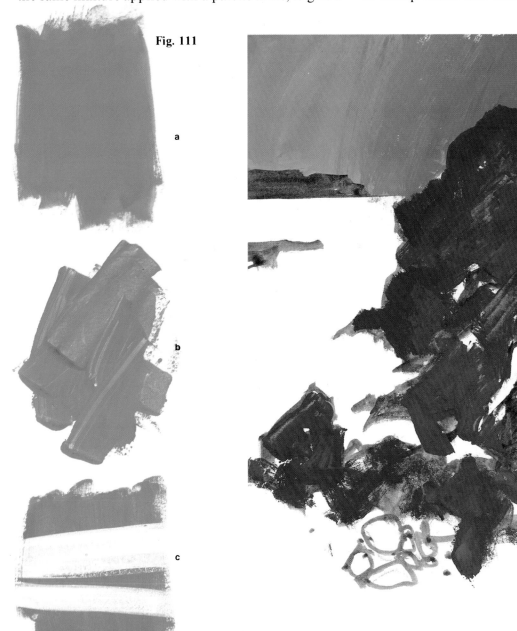

Fig. 112

Fig. 111

a

b

c

63

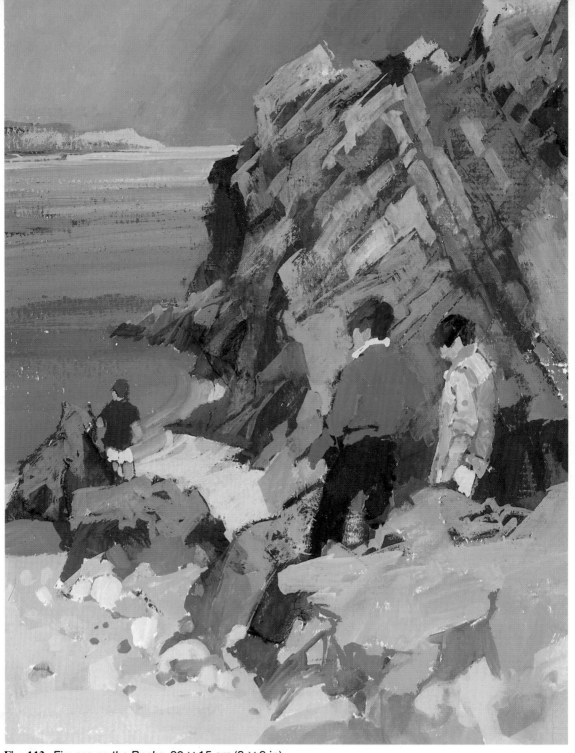

Fig. 113 *Figures on the Rocks*, 20 × 15 cm (8 × 6 in)

painted the rocks with mixtures of Burnt Umber and Olive Green to which I added acrylising medium, applying the colour with a palette knife to give slabs of texture.

In **fig. 113** you will see that by using acrylising medium I was able to overpaint light falling on the rocks without pick-up, and for this I used Cool Grey 1, Permanent White and Raw Umber. I painted the figures with Burnt Sienna, and Viridian Green with Permanent White, then painted the sea to reflect the sky. For the beach I used mixtures of Raw Sienna with Permanent White and Olive Green with Permanent White.

Having been asked on so many occasions 'What is gouache?' I hope that in writing this book I have helped both to dispel any mystery and to convey my enthusiasm for the medium. Gouache is so versatile that it suits almost anyone's style of painting and when used with other media or with the addition of acrylising medium its scope is even wider and more exciting.

Remember that painting is not easy – if it were it would not be so rewarding – and that any medium that is new to you adds an extra challenge. There are no short cuts to painting – the only way to learn is to pick up a brush and try.